THE acrylic paint
COLOUR WHEEL BOOK

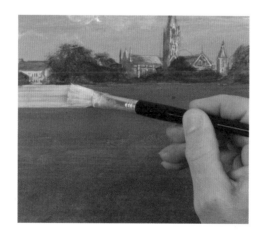

THE acrylic paint
COLOUR WHEEL BOOK

john barber

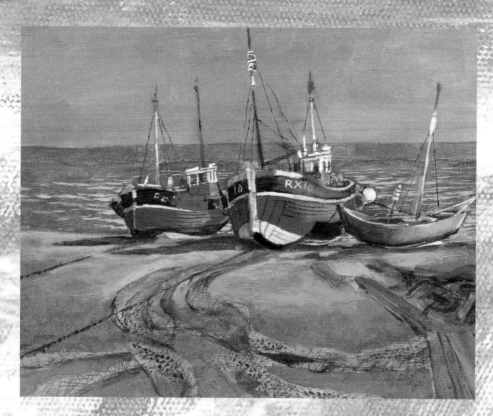

Search Press

First published in Great Britain in 2009 by
Search Press Limited
Wellwood, North Farm Road
Tunbridge Wells, Kent TN2 3DR

Copyright © Axis Publishing Ltd

Created and conceived by
Axis Publishing Ltd
8c Accommodation Road
London NW11 8ED
www.axispublishing.co.uk

Creative Director: Siân Keogh
Editorial Director: Anne Yelland
Designer: Simon de Lotz
Production: Jo Ryan
Photography: Sean Keogh

ISBN: 978-1-84448-421-8

The publishers and author can accept no responsibility for
any consequences arising from the information, advice
or instructions given in this publication.

Readers are permitted to reproduce any of the material
in this book for their personal use, or for the purposes of
selling for charity, free of charge and without the prior permission
of the Publishers. Any use of the material for commercial purposes
is not permitted without the prior permission of the Publishers.

Suppliers
If you have difficulty obtaining any of the materials or
equipment mentioned in this book, please visit the Search Press
website for details of suppliers: www.searchpress.com

Printed and bound in China

contents

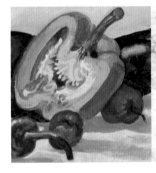

egglant with peppers

Arrange a group of simply
shaped vegetables with a
light to create highlights,
then paint what you can
see in front of you.

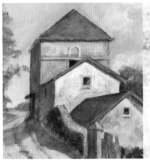

french farm buildings

Reduce farm buildings to
a series of geometric
shapes, then build the
colours of crumbling
masonry and roofs.

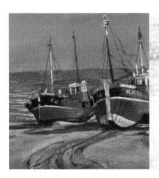
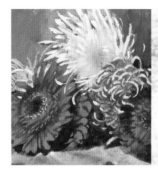
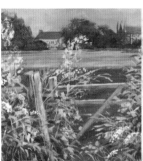
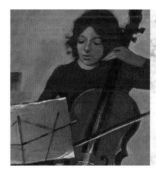
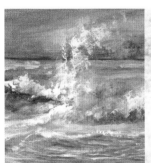
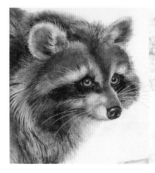

introduction

Acrylic colours have come to be used almost universally in the arts. A difficulty that arises in writing an introduction to painting with acrylics is that compared to every other medium of painting, it has almost no history. Compared to the centuries it took for oil painting to arrive at the refined techniques that exist today, the widespread use of acrylics has come about in a relatively short time but there now exist many paintings made half a century ago so that it is possible to ascertain the durability of these materials. The writer, however, cannot point to technical or stylistic development over centuries. Acrylic paints, developed originally by the automobile industry, were quickly taken up by all types of artists who saw the endless possibilities of a paint medium which could incorporate all the traditional pigments, plus a wide range of new organic colours. These are extremely brilliant and pure and approach more nearly the ideal colours of the spectrum. They can be used in the manner of the older mediums like watercolour, gouache, oil, and tempera and yet have none of the techinical limitations.

Acrylics do not require that the painter pays attention to time-honored formulae and rules. All difficulties about drying times, painting mediums and possible cracking associated with oils can be forgotten by the modern painter. In fact, the old rules need never be learned as acrylics have made a long craft training obsolete. This means in essence that anyone who wishes to paint can start at once to apply paint in any way they choose with few technical considerations. The untrained amateur, uninfluenced by dogmatic teaching, can produce fresh and exciting work from the first day, the only limits being their own inhibitions. Most of the leading names in modern art have adopted acrylic as their medium of choice with hard-edged abstraction made easy by the quick-drying paints. Roy Liechtenstein's (1923-1997) giant comic illustrations and Andy Warhol's (1928-1987) soup cans are examples of modern-day icons created in acrylics.

The renewed interest in the minor crafts of furniture decorating, model- and toy-painting is due to the ease with which acrylic paints adhere the many surfaces, even bare wood and stone. Great durability is given to the work by tough, flexible and quick-drying acrylic varnishes. Most modern mural work is now carried out in acrylics, with much use being made of the great range of domestic decorating paints which are made using polymer acrylic emulsions. Artist's acrylic colours can be readily mixed with these to strengthen or alter their colours.

understanding colour

What the great artists showed is that successful painting often depends as much on the effects created by your colour choice as on composition, which is where an understanding of how colour works comes in.

Look at the colour wheel (right) to see how colours are grouped. For each picture you paint, you will need an acrylic colour to represent each of the primary colours so that by

THE COLOUR WHEEL

The colour wheel is great reference for artists. The three colours in the centre are the primary colours. Primary colours are the ones that cannot be obtained by mixing other colours together. The middle ring shows the colours that are created when you mix two of the primaries. Red and yellow makes orange; blue and yellow makes green; blue and red makes purple. These are called secondary colours, and show the colours you can expect to create when you mix primary acrylics in your palette. All colours can, in theory, be created by mixing varying amounts of the primaries. The outer ring breaks down the secondary colours further into 12 shades.

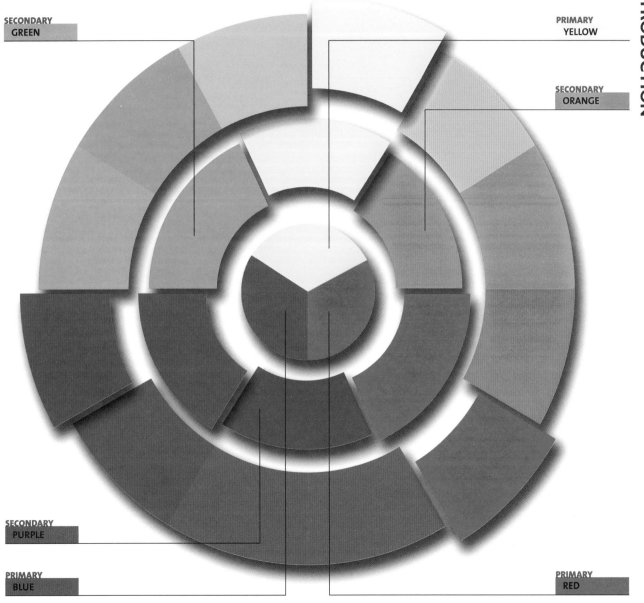

SECONDARY
GREEN

PRIMARY
YELLOW

SECONDARY
ORANGE

SECONDARY
PURPLE

PRIMARY
BLUE

PRIMARY
RED

COMPLEMENTARY COLOUR

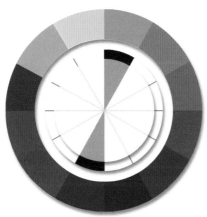

The colours that are opposite each other on the colour wheel are called complementary colours. These work together to create a harmonious reaction. Try using them side-by-side in your work – they will each appear to be stronger by contrast, bouncing off each other.

COLOUR TERMS

HUE
Hue indicates the strength of a colour from full saturation down to white. In practical terms, if you buy any colour labelled 'hue' it means that the colour is less than full strength. This is used as a way of reducing the cost of expensive pigments.

TONE
Tone is the degree of darkness from black to white that creates shade and light. For example, in a black-and-white photograph you can see and understand any object independently of colour, solely by its graduation from light to dark. The word 'shade' is often used instead of 'tone'.

COLOUR
Colour results from the division of light into separate wavelengths, creating the visible spectrum. Our brains interpret each wavelength as a different colour. The colour wheel is an aid that helps us understand how colours are arranged in relation to each other.

TRIADIC COLOUR

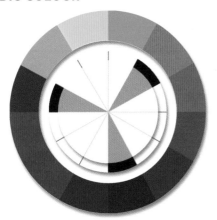

Triadic colour occurs when a 'chord' of three colours is used in combination. A mixture of any two colours of the triad used next to a third, unmixed, colour will give many different effects. A triad of colours from any part of the wheel is the basis for a good colour composition.

SPLIT COMPLEMENTARY COLOUR

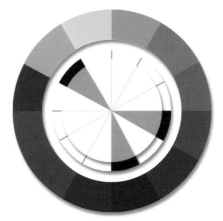

Split complementaries create three colours: the first colour, chosen from any point on the wheel, plus the two colours that come on either side of the first colour's natural complementary colour. These three colours will give plenty of unexpected colour schemes.

mixing them, you can obtain all the secondary colours. The primary colours you choose should be determined by the scene you wish to paint. For example, if you are painting cool clear skies and distant hills, choose cobalt blue to represent blue in the colour wheel; permanent rose to represent red; and cadmium lemon to represent yellow. All three colours are cool, enabling you to maintain a consistently cool palette – no clashing 'hot' colours will appear. Likewise, when painting a warm scene, use a warm blue, red, and yellow for your primaries. This idea, along with using complementary colours, which appear opposite each other on the colour wheel and produce harmonious contrasts, will help you keep all the colours you choose balanced.

A good exercise is to make your own colour wheels for warm and cool colours. Draw several circles 10cm (4in) in diameter and divide each circle into six pie slices. Paint your three primaries in alternate slices and then mix them: red with yellow for orange, blue with yellow for green and blue with red for purple. Place these secondary colours in between the primaries and you will see exactly which ones work out well for your picture. Keep this worksheet as a reference palette.

taking style cues

Look at all artists' work, old and new, for ideas and inspiration. Research as many examples as you can, learning each artist's methods and techniques. This does not mean that you should try to produce exact copies of their work, but by your review you will develop your own knowledge and taste.

This book goes hand-in-hand with your own research into subjects for the artist by providing a wealth of instruction on just what can be achieved with acrylics. Highly accessible, practical, and instructional, what you will

gain from it in technical skill will give you the competence that leads to confidence. It is this confidence that will enable you to express your thoughts in paint – it is easy to forget in the struggle to master materials and techniques that the real aim of painting is the expression of ourselves. Good technique and practical skill make this personal expression a great deal easier.

INDOOR/OUTDOOR TEST

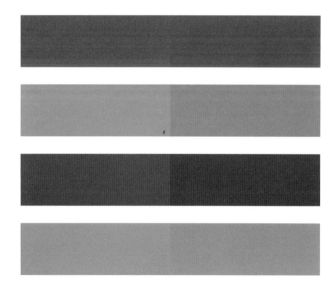

The indoor/outdoor test is designed to show the effect that artificial or subdued lighting has on colours when compared to daylight. If you look at the four strips indoors you can see hardly any difference between the colours on the right compared to the ones on the left. Step out into the daylight and you will be able to see that the right-hand side is noticeably darker. This sort of phenomenon plays an important part in how we perceive colour and all artists have to be aware of it. Although it is never quite as obvious as in the experiment, it does help to explain why art studios are built with high skylights, ideally facing north. For artists whose pictures depend on great colour accuracy, good daylight is an essential need.

The atmosphere of this picture is created by the all-pervading red of the underpainting. Even the greens and blues are brought back toward the warm end of the spectrum, with all sorts of subtle purples holding the harmonies of colour together to beautifully evoke a mysterious Parisian twilight.

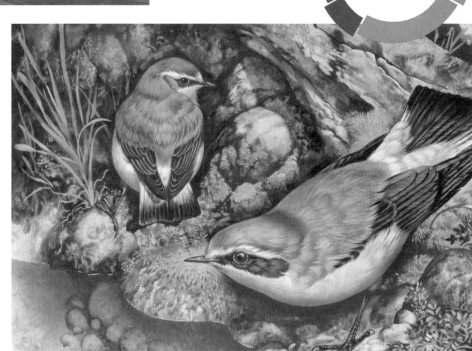

This detailed scene contains a wealth of texture and modelling, but the dominant colour note is the cool grey of the cock bird's back and in combination with the bright yellow-greens and the blue-grey of the rocks, hardly leaves the cool blue end of the palette, except for the blush of sienna on the bird's throat.

The woodland trees in winter filter the weak sunlight into patches on the forest path. A dominant motif of thin vertical lines gives the picture a feeling of repose while the blurring of the trunks by the low sun adds the element of infinity.

Ultramarine and raw umber keep all the tints cool, and weak yellow ochre warms the snow colour where the sun penetrates the mist. This painting amply demonstrates the value of using only a restricted palette of colours in some of your works.

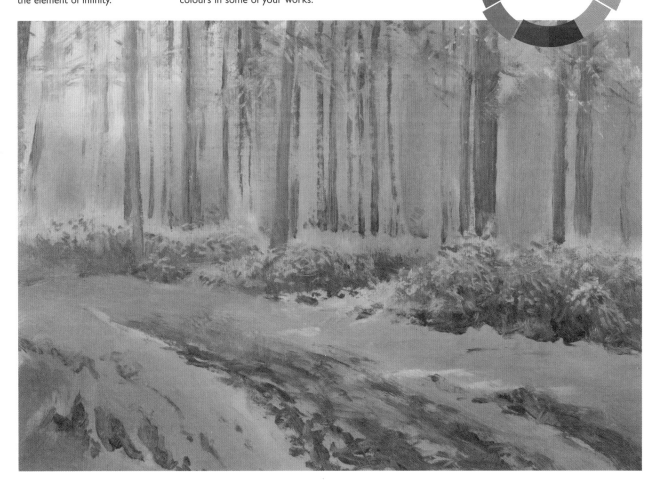

how to use this book

The jacket of this book features a unique colour-mixing wheel that will show you the shade that will result when you mix equal quantities of two colours. The colours have been chosen as the ones that are most useful to artists working in acrylics. A glance through the projects in this book will give you an indication of the enormous range of colours and tones that can be achieved using these colours. Each project lists the colours you will need and highlights how to mix them to achieve the shades you need.

USING THE COLOUR-MIXING WHEEL

The colour-mixing wheel can be used to help you determine what the result of mixing any two colours from your selection will be. It can also be used if you are unsure of how to achieve a shade you wish to create, from nature for example. Turn the wheel until you find a shade in one of the inner windows you like and read off the two colours you need to mix to achieve it.

THE
acrylic paint
COLOUR WHEEL BOOK

permanent rose
violet
cadmium red
cobalt blue
orange
ultramarine
cadmium yellow
payne's grey
cadmium lemon
viridian
yellow ochre
burnt sienna

① turn the wheel to align the desired colour combination

② the resulting colour will be seen in the indicated window

+

eight step-by-step projects and a unique acrylic colour mixing wheel

●turn

outer colour wheel
The colours on the outer wheel are the standard acrylic colours you will need to get started.

inner colour wheel
Colours on the inner wheel repeat those of the outer wheel.

mixed colour
This window reveals a swatch of the exact result of mixing equal quantities of the colours on the inner and outer wheels.

turn the wheel
The wheel turns so that you can line up the two colours you intend to mix and see the result in the window.

finished painting
The project begins with the completed painting to give a sense of its overall scope and complexity. This is then broken down into several steps, gradually building the work.

picture details
The title of the finished piece of work, together with the artist's name are given. Also included is the size of the work, to give you an indication of scale.

what you will need
All the materials and equipment you will need to complete the project are highlighted at the start so that you can have everything to hand.

6

Bunch of flowers
john barber
400 x 500mm (9 x 12¼in)

Flowers have been favourite subjects for artists since painting began. In this project the subject was not arranged, but an attempt was made to render the flowers just as they fell on the table with their wrapping paper under them. The main interest is the contrast between the strong disk-like form of the red flowers and the spiraling white petals in the centre. The concentric circles of petals, which get larger as they spread, are painted as blocks of colour, particularly where they catch the light around the edges. Their lighter tone, although not closely detailed, provides more information about their structure. By contrast, the lighter flowers flow freely around, and define the shape of the orange flowers with points of light.

WHAT YOU WILL NEED
Canvas board
Brushes: flat hoghairs nos 2, 3, 4, 6, and 9;
round sable no. 3
Kitchen paper

COLOUR MIXES
1 Payne's gray
4 Yellow ochre
5 Cadmium lemon
6 Cadmium yellow
7 Orange
8 Cadmium red
10 Violet
12 Ultramarine

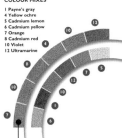

TECHNIQUES FOR THE PROJECT
Painting from dark to light
Glazing
Building solid highlights

techniques for the project
Different techniques are used in every project to build up your experience and confidence.

colour mixes
The colours used in the project are shown, together with the colours they are mixed with, to create the finished work.

14

6

bunch of flowers / techniques

PRECISE KNIFE PAINTING

The basic techniques of acrylic painting are simplified by the fact that the only substance needed to dilute your paint is water. Acrylics lend themselves to use in the early stages of a painting, when thin transparent washes, made from the paint as it comes from the tube, watered down as required, is all you need to get your canvas covered. If the paint is not thoroughly mixed, but allowed to be carried in the water, many textures of stripes and bubbles will be left when the water has dried. The exploitation of these qualities can give immediate results that are so attractive you may not want to elaborate any

further. A disadvantage is that it is difficult to lay a flat wash in transparent acrylic and, if you need an absolutely flat finish, the addition of some white is going to prove essential. Many areas in the bunch of flowers study have this first wash quality and, in a more finished picture, would be built up in solid layers of opaque paint to give more subtle modelling and colour matching. However thick the paint on your more finished paintings, you still have the option of applying transparent glazes which are the same as your first washes at any time without running the risk of any technical problems.

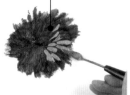

3 Now start making marks using your smallest palette knife. Gradually move around the flower, keeping the lighter patches separate at this stage. You will be adding some modelling onto the leaves later in the study.

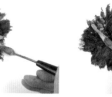
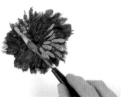

4 Make distinct marks by touching the canvas firmly and then lifting the knife. Gradually add to the circle of marks. Turn the canvas around so that without moving your hand you can make the same shaped marks all around the flower.

1 In this project, you will be working through the first stages of painting a blossom. Mix up your flower colour without adding white and, with a small hog brush, drag each brushstroke out from the centre so that any brushmarks will radiate outward.

2 Adding some white to your colour mix will give you a tonal contrast for the next stage which is suggesting the light on each petal. Do not tidy up the darker colour but concentrate on making petal shapes with the palette knife.

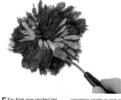

5 You have now reached the stage where your marks can be allowed to overlap or touch each other. Try to complete concentric circles as part of the practice. When they are dry, glaze background colour over some of the lower petals.

6 This exercise has been designed to give you experience in controlling the palette knife before you tackle the project on the bunch of flowers when you will have the choice of using either brush or palette knife.

step by step
The project is built up in detailed steps right from the first sketched marks to the finished piece of work, enabling you to create a work of your own using these techniques.

detailed practice
Practical photographs of good working practice in using materials show the artist building up the work.

artist's advice and tips
A practising artist offers information and advice based on his experience of materials and equipment and methods of working.

122

6

bunch of flowers

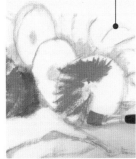

There are some areas of white canvas glinting through still. Don't worry too much about detail at this stage, but do look at the shape of the flowers and note that they are not perfect ellipses. The petals fall in a random way.

RIGHT Work some darks into the green curly blossom. This is a mix of ultramarine and cadmium lemon and will be used for the green foliage.

STEP 4

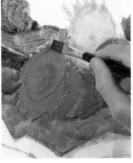

RIGHT Start to put the background colour in as a thin wash, to help you to judge the strength of the flower colour. This is a mix of violet and orange. Note how much brighter the orange looks once the violet paper is added.

The paper still has some folds and texture in it. The texture can be left or overpainted later. Use the violet to cut out the shapes of the leaves.

STEP 5

Tone down the other piece of wrapping paper so that it is not too stark. Use a thin wash of background colour with yellow ochre added. Apart from the leaves, all canvas now has some colour on it.

RIGHT Make the darks stronger by adding a little violet to the orange. Use the no. 9 brush to keep a broad feeling to your brushstrokes. Build in some darks, using a stiffer mix of paint.

STEP 6

Note at this stage that there is a subtle double row of petals on the orange flowers, and that there are shadows on the left of the flowers and cast shadows on the right. Now, go back to the no. 4 brush and put a glow of cadmium lemon into the centre of the white flower.

123

LIGHT AND SHADE
Don't be frightened to make full use of shadows in your compositions. In the early stages it is easy to be concerned that you are darkening all your 'brights' too much, but here the brightness of the flowers will be recovered once you start to add white to your paint mixes. At the beginning of a composition, simply establish the pattern of light and shade.

PROJECT 6 / BUNCH OF FLOWERS

STEP 7

pull-out detail
For clarity, some areas of the work are highlighted in greater detail, enabling you to see exactly what shade or effect you are looking for.

clear steps
Each project builds up in numbered steps, with precise details on what to mix and how to add colour and detail.

guided steps
All the steps are clearly outlined, as the project builds up. Following all the steps results in the finished picture.

materials & equipment

Artists in acrylics choose their equipment with care. This section explains what you need in order to create successful works of art in acrylics and examines the range of materials you will find in your art store or online. Paints, canvases and other supports, brushes and useful accessories are described and illustrated.

materials & equipment

Getting started in acrylics does not involve buying a great deal of equipment. Buy a couple of brushes, a few tubes of paint, a pad of paper or a couple of canvas boards and you are ready to start. You may find that you have most of the other materials you may find useful, such as pencils and charcoal, already. These are inexpensive to add to your painting kit. If you do not want to spend more, you can always use a small brush and dilute paint as your drawing tool, as is the case in project 6. You can work almost anywhere and the results are highly durable. Experiment with how paints handle by using them directly from the tube, then dilute with a little water and look at the differences in the marks and finishes you can achieve.

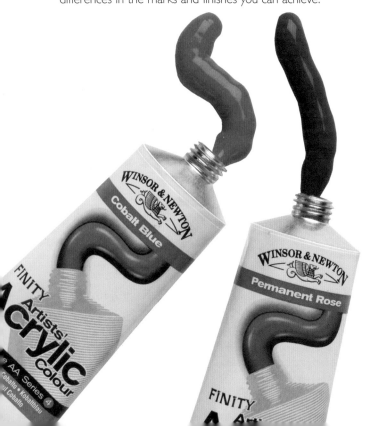

As a general rule, buy the miminum you need to get you started and then add to your materials and equipment as you work out what suits your subject matter and ways of working.

paints

Acrylic paints are vibrant, water-soluble, permanent when dry, and will not yellow with age. Without becoming too technical, it is the new artificial organic pigments prepared in the laboratory that have brought a new range of brilliant and deep colours to the artist's palette. They are more permanent and stable than any other pigments. Phthalo, cyanine, quinacridone, azo and naphthol are the names associated with these pure new colours. Unlike oil painting, where the pigments are mixed with any number of combinations of oils, essences and resins and the exact mixtures require some skill and training, acrylics are mixed with a single polymer emulsion. This liquid, which is milky-white when fluid, mixes readily with any amount of water so that acrylic colours can be diluted to thin washes like watercolours or used straight from the tube like oils, and every degree of mix in between. Even the thickest applications of acrylic will not crack.

The polymer resin also carries the traditional mineral pigments used in the older painting media. It can even cope with the addition of texturing materials such as sand, glass, and metal powders and, since it dries crystal clear, reveals their reflective appearance. Perhaps its great advantage over oils is that it dries so quickly that many layers of thick paint can be applied and even glazed and scumbled within a single day without the risk of wrinkling or cracking. However, if you find that this does not suit your way of working, retarding liquids can be added to slow down the drying process.

Acrylics allow almost any method of application by brush, knife, or squeegee and can be diluted for spraying. With acrylics, almost any alteration can be made by repainting over what has already been done, without technical difficulties. This cannot be said of oils, watercolour, or gouache.

You do not need an enormous number of acrylic paint colours to create works of art with plenty of contrast in terms of subject matter and colour use. The eight projects in this book were painted using only 12 main colours, with the addition of black and white. If you are new to the medium, buy a set of 10–12 artists' quality colours and add more colours as your work evolves. The colour needs of a landscape painter, for example, are different from those of a portrait painter.

PAINTING OUTDOORS

Painting from nature is a great way to improve your skills. Sun and cloud constantly change the landscape, allowing you to pick and choose what you include in your artwork. A great advantage of acrylics is their quick drying time, which makes them very suitable for painting outdoors, since you are unlikely to have to carry wet artwork home. Take a portable easel, a large and a fine brush, one or two canvas boards or a couple of sheets of acrylic paper, your paints, and a disposable palette. Make sure you have a folding container for water and hook it onto your easel so that you don't accidentally knock it over.

grounds or supports

A wide variety of surfaces are suitable for acrylic painting. These pages present the most common and then offer a few pointers on less usual, but also successful, surfaces.

canvas

For artists who choose to use acrylics as quick-drying oil paints, canvas is the most popular surface. The finest and most expensive canvases are made from linen but cotton, which was introduced later and is not quite so durable, is also excellent as a support. Both these materials are produced in grades from very fine, where the threads of the weave hardly affect the painting surface, to really

coarse textures that break up the paint into dots. For extremely large areas, such as scenery painting, hessian is often used as a cheap alternative to canvas. Canvas is usually supplied tacked to light wooden frames that can be tightened by tapping small wedges into the corners. You can also buy canvas by the yard and stretch it yourself.

Canvas boards are widely available in all grades and sizes. They are made by gluing canvas to a heavy cardboard base and are a convenient and light alternative to stretched canvas for small- to medium-sized works, up to approximately 600 × 500mm (24 × 20in): larger-sized

OPPOSITE Canvas, tacked to a stretcher for tightening, is available in many sizes and is usually sold primed and ready for painting. Canvas boards too are sold in many different shapes and sizes. Boards are also usually primed and ready to paint on, and can be tinted any colour.

BELOW Papers suitable for acrylic painting are sold as individual sheets and in pads of many different sizes and weights. A good general weight is 250gsm (150lb). These are ready to paint on immediately. Other papers need sizing and priming before paint is applied.

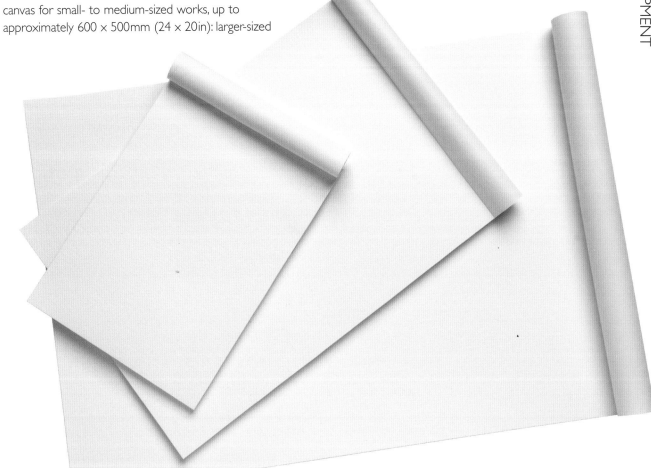

boards have a tendancy to warp. Canvas boards can be cut down to a smaller size with a craft knife if you wish to alter your composition.

panels

Large wooden panels, which were in use before canvas became popular, were always unstable and expensive to make. Masonite was often used as an alternative, but this has been superseded by an excellent modern replacement material, MDF (medium density fibreboard).

MDF is inert, does not warp, does not attract insects and if properly sealed and primed, is a fine support for all artists who prefer a smooth surface to work on. When primed with gesso (plaster and glue) it provides a surface comparable to those used by the Old Masters.

paper and card

Paper and card are delightful to paint on, and provided they are sized with glue to prevent paint soaking into them, are technically sound. Watercolour papers can be used, but need to be stretched before you start work. You can also buy pads of acrylic paper, which need no preparation before you start.

other surfaces

Any non-greasy surface is suitable for acrylic paints. Many fine pictures have been painted on copper, and aluminium, provided that it has a 'tooth', can also be used. Acrylics can also be painted onto glass, fabrics, and furniture.

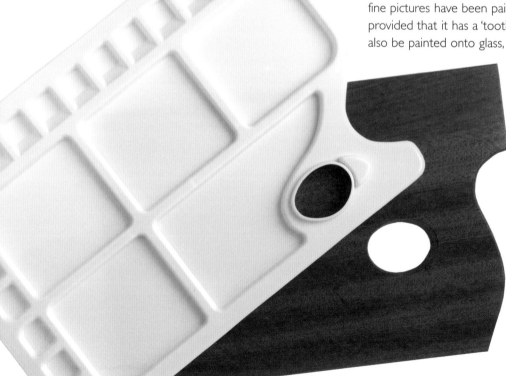

A smooth flat surface is useful for laying out and mixing your paints. An artist's palette in wood is one of the most common types and the thumbhole is useful, especially if you stand to work. Palettes designed specifically for acrylics are also available in plastic, with wells to hold colours from the tube and areas for mixing.

There are gels and retardants that slow the drying time of acrylics, to give you longer to move your paint around on your support. A flow enhancer may improve paint movement. Acrylics can also be mixed with a gloss or matt varnish to dry to a clear and glossy or dull finish. The best way to find out whether these products are useful is to practice with them.

Palette knives are useful for mixing paint on the palette, in addition to applying paint to board or canvas. The trowel-shaped models are lightweight and flexible. The edge of the knife should be smooth to lift paint easily and apply it to your painting surface.

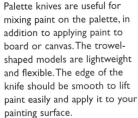

palettes

Medium-sized rectangular palettes with a thumbhole are the most practical. They are sold in wood, and obviously the reddish colour will affect the way you see your colours when you are mixing them on the palette. The wood colour matched the tinted canvases used in the past but is not helpful if you work on a white canvas. A good alternative is a white plastic palette of the same size. Choose one with tray indentations if you work with fairly loose paint. If you have a painting room, a sheet of heavy glass laid on a table is ideal and you can put a sheet of coloured paper to match the tint of your canvas underneath it. If your sessions are frequently interrupted, consider a moisture-retaining palette.

palette knives

Like oils, acrylic paints can be spread or manipulated using knives or spatulas, in metal or wood. A whole range of

knives shaped like miniature trowels can be used to develop a style in which a whole picture is painted without brushes, or with minimal brushwork. The combined use of brushes, with palette knives being used to add emphasis of solid colour, is very effective in achieving dramatic results. Knives were most famously used by Gustave Courbet (1819–77) who is credited with the development of the trowel-shaped blade and offset handle, which gives greater ease of paint handling.

brushes

The most popular brushes for acrylic painting are made from hoghairs. These are stiff yet springy and will either smooth the paint into place or plough through the paint to move it. They are made in many shapes and sizes: round, flat, and filbert are the main types to consider. Filberts are the full-bodied, oval-sectioned brushes that come to a point.

Brushes for acrylic painting are produced to the same quality standards as those for watercolour. Generally, they have longer handles to allow you to paint standing back from your work to monitor its progress as you go. Buy fewer, good-quality brushes, rather than putting together a comprehensive collection of cheaper ones. All artists develop their favourite brushes and use them time and again, regardless of subject, so you may find you have a box-full of brushes you seldom use.

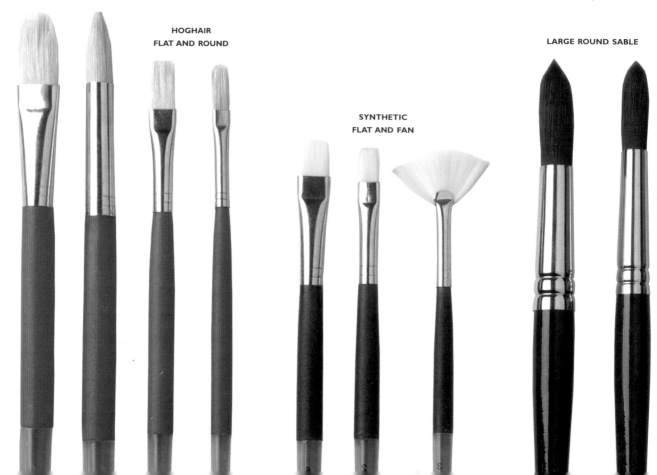

HOGHAIR FLAT AND ROUND

SYNTHETIC FLAT AND FAN

LARGE ROUND SABLE

ANATOMY OF A BRUSH

HAIRS
Many kinds of animal hair have been used to make brushes, the best of which is sable. A wide variety of synthetic fibres is also available, which now compare well with sable hairs.

FERRULE
The ferrule is the metal tube that holds the hair and attaches them to the handle. Avoid brushes that have a seam or join on the ferrule – these don't grip the hairs or wood well.

HANDLE
Handles are often made from wood that has been varnished to make it watertight. The brush handle is usually widest at the ferrule, the point at which you usually hold the brush.

FLAT AND ROUND SABLE

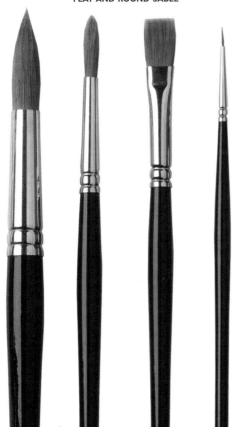

WHICH BRUSHES TO BUY

Choose a small selection of hoghair brushes, say two each of flat, round and filbert of a size that you feel comfortable with. You will also need a medium-sized round sable and a long-haired 'rigger' brush in sable or synthetic fibre. A couple of decorator's brushes are useful and inexpensive, especially if you plan to work in a large scale.

When buying a round brush, ask for a sample, dip it in water and, holding the end of the handle, flick it downward. Discard any brush where the hair does not come to a neat point. Do the same with flat brushes, which should come to a smooth, flat edge. Also take the ferrule in one hand and twist the handle with the other. If you can feel any movement, do not buy the brush.

Note that you can use your watercolour brushes for acrylic paints, but you will not get the same 'response' if you then go back to using them for watercolour.

BRUSH CARE

If you purchase a good range of brushes and take care of them as you use them, they should last a lifetime. One of the most important things to remember about acrylic paints is that, although they are water based, they are water resistant when dry, so if you let paint dry on a brush, it can be difficult to remove. For this reason, don't leave a brush with paint on it to harden.

While painting, soak your brushes in water or solvent so that the paint does not dry in the bristles. It is well worth buying a brush holder to hold your brushes in liquid, without bending the bristles. Never leave brushes standing in your water jar with the bristles facing down. This causes the points to curl round and, although they usually straighten after a while, they are difficult to use while the hairs are curved. Do not discard brushes if they lose their point completely – they can still be used to lay washes, as you would in watercolour.

After a painting session, wipe any excess paint from your brushes using a rag or some kitchen paper. Always rinse your brushes in plenty of lukewarm water until the water runs clear: very hot water can damage the ferrule. If a colour has dried on a brush, use an artist's brush cleaner to remove it. When the brush is clean, blot any excess water with a towel, reshape the hairs between your finger and thumb and leave to dry, standing upright on its handle.

Take care not to ruffle the hairs when carrying your brushes by using a brush case, which is simply a cylindrical metal tube with a lid, or by securing your brushes with elastic bands to a stiff piece of cardboard.

Try a few of each before buying the whole range. Sable and synthetic hair brushes are all useful to painters in acrylics, especially those who choose to work with colours of a more liquid consistency.

Kolinsky is the name given to the sables of the highest quality. Another type called 'mongoose' is useful because these have the softness of sable and springiness of hoghairs. There are also synthetic brushes that closely match these qualities, usually at a fraction of the price. Very long-haired brushes in sable, called riggers, are used for drawing out fine lines.

It is useful to include a few decorators' brushes up to about 75mm (3in) wide for priming and tinting backgrounds. Of the many technical brushes that exist for the subtle blending of paint, the fan brush in hog, sable, synthetic and the 'badger' blender are the most useful. Buy a few that take your fancy and practice with them until you understand their quaities and what they can be used for.

easels

If you are planning on working on large pieces, or on portraits, you may find it most comfortable to do some of the work standing. If that is the case, you will need to secure your work so that it does not wobble or shake. The classic studio easel has a ratchet mechanism, a tilting frame with winding handles, and locking castors so that it can be wheeled around the studio, but for most people such elaborate pieces of furniture are unnecessary, although they certainly look impressive in the studio.

More usual and essential for serious work is the radial easel, which can cope with pictures up to 1m (3ft) square. A tripod sketching easel is adequate for most small pictures. The metal ones are more stable owing to their extra weight and rigidity, but less good for outdoor work. Camera tripods with a drawing board bolted to the camera plate are a good alternative.

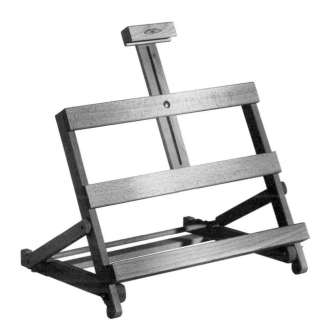

A tabletop easel is ideal for smaller works. If you are working on paper, tape your paper to a drawing board and lean on the easel. Choose a model with two or three angles of adjustment to meet your precise needs.

A floor-standing easel is a good investment if you are going to be doing a lot of painting. Choose a model with an adjustable angle of working, and with adjustabe legs so that you can work standing or sitting, and can compensate for any uneveness in the floor.

A desktop easel is useful if you prefer to sit at a table to paint and are working only on small to medium pieces. These have the advantage that you can fold them away for storage when you are not painting.

other useful equipment

A desk light is an essential for colour mixing in dim light, and can also help you to orchestrate the lighting of your still life compositions. Finally, pencils, chalks, charcoal and a putty eraser may all prove useful.

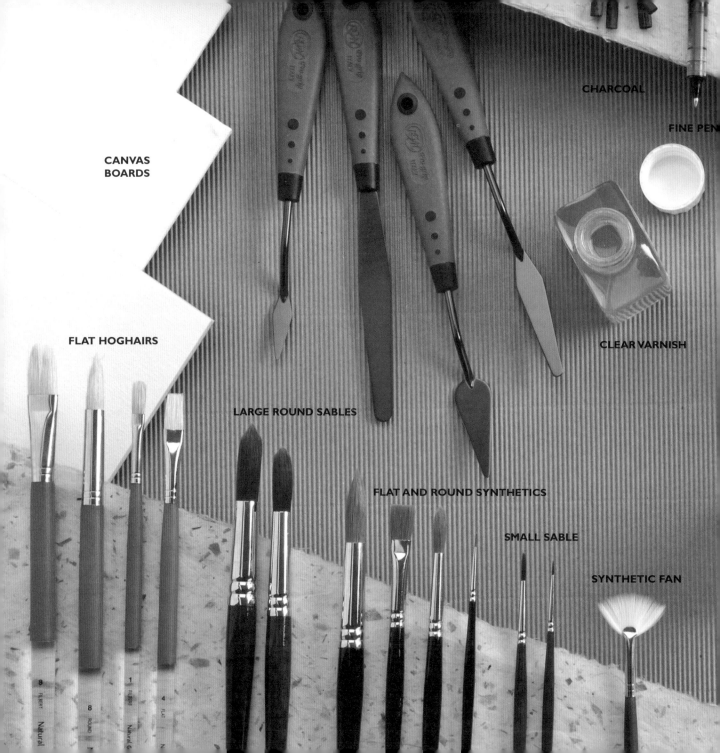

CANVAS
BOARDS

CHARCOAL

FINE PEN

CLEAR VARNISH

FLAT HOGHAIRS

LARGE ROUND SABLES

FLAT AND ROUND SYNTHETICS

SMALL SABLE

SYNTHETIC FAN

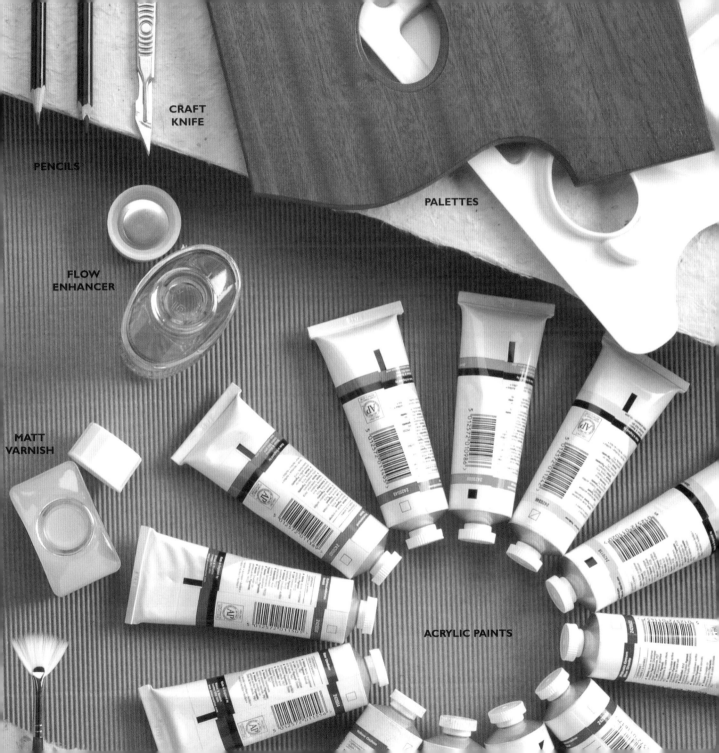

PENCILS

CRAFT
KNIFE

PALETTES

FLOW
ENHANCER

MATT
VARNISH

ACRYLIC PAINTS

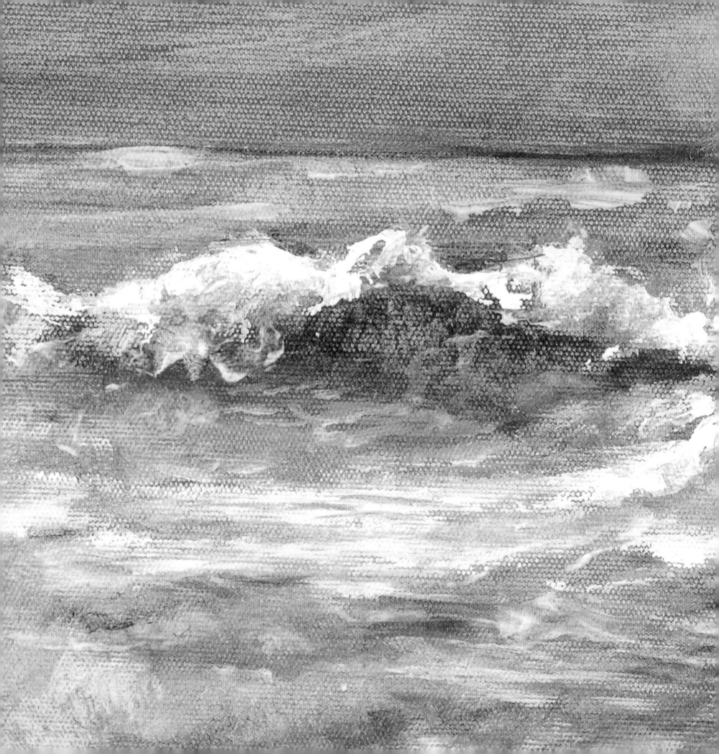

basic techniques

Before you can put brush to paper or canvas, you need to know how and where to start. This section gives clear advice on the main techniques you will need to master to paint using acrylics: Making and controlling marks, understanding transparency and opacity, mixing tones and preparing your grounds and supports, ready to start painting.

basic techniques

The basic technique for acrylic painting is simple. Add water to any colour or combination of colours, just as they come from the tube and apply with brushes, knives, spatulas and even your fingers, if you wish. Alternatively, squeeze your tubes straight onto the canvas and then begin to manipulate colours using tools of your chioce. There is hardly a style of painting to which acrylic paints cannot be adapted – from fine detailed botanical, natural history, or architectural illustration to large abstract works featuring blocks of solid colour and every kind of representative art in between, as the projects in the rest of the book demonstrate. Acrylics are far easier than watercolours for the beginner, since contrast alterations can be made without detriment to the finished result. Whole passages can be covered with solid white paint and repainted to match the rest of the picture. This would not be possible in watercolour, which is a purely transparent medium, or with oils, where the drying times would make the method risky.

CONTROLLING THE MARKS YOU MAKE

It may be banal to say that all painting depends on getting the paint exactly where you want it in your picture. But controlling this one task is essential to expressing your intentions in paint. Your brushes, how you hold them, their size, shape and stiffness, as well as the amount of paint you load them with all contribute to your touch on the canvas and give a unique character which marks out your work from all the others, even at an early stage in your painting life. There is no substitute for practising making marks.

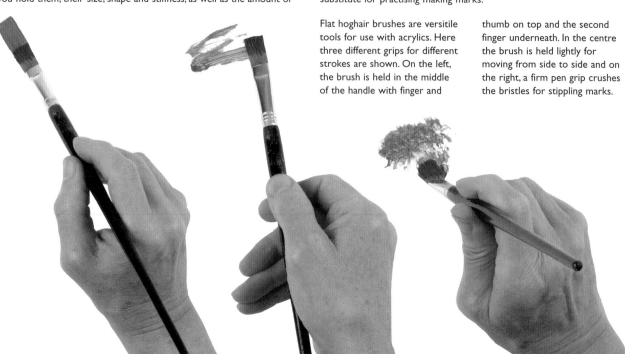

Flat hoghair brushes are versitile tools for use with acrylics. Here three different grips for different strokes are shown. On the left, the brush is held in the middle of the handle with finger and thumb on top and the second finger underneath. In the centre the brush is held lightly for moving from side to side and on the right, a firm pen grip crushes the bristles for stippling marks.

STIPPLING

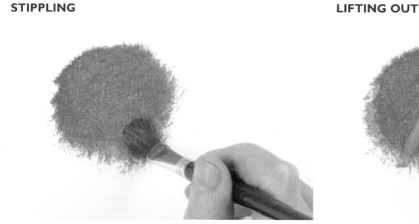

LIFTING OUT

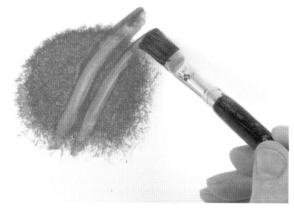

For stippling and covering areas with textured colour but without directional strokes, hold the brush with a pen grip at the broadest part of the handle right above the ferrule and tap repeatedly downward.

While the patch of paint is still wet, dip the clean brush in water and, using the edge of the bristles, clear out lines and shapes. If necessary, repeat these movements until the canvas appears again.

On the far left, the brush is held toward the far end of the handle to give you greater pressure to push the paint on. In the centre, the side of the bristles are gently tapped, without pressure, to give broken marks. The third example shows angling the edge of the brush to make lines. Here hold the thickest part of the handle.

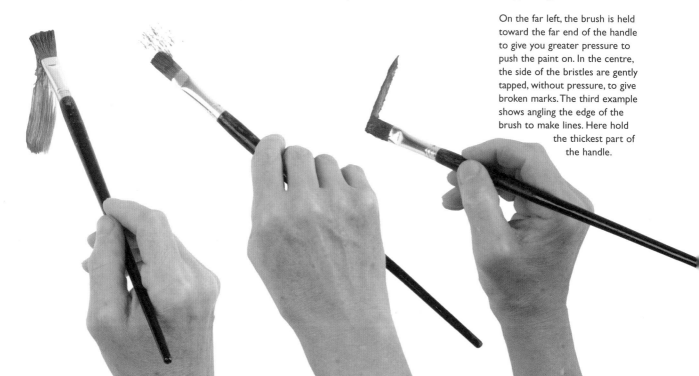

With gouache, more than one layer of paint is liable to flaking, which is not a worry with acrylic, since flaking hardly ever occurs. In addition, acrylics will adhere to almost all surfaces from smooth illustration board to highly textured canvas. You can also prime metal, wood and other surfaces with some 'tooth' to take acrylic paints with some success.

colour selection

With the range of acrylic paints available today, you should have no difficulties in furnishing your palette with all the colours on the colour wheel illustrated on the cover of this book. In addition to this basic spectrum of colours, there are many that can be substituted to give a completely different colour selection so that sets of three primaries can be put together to express your intention for any type of picture. For instance, if you wish to paint a rich sunset, you would need to be very careful about the type of red you select as your first primary colour. Whether you select a purply red like alizarin crimson or Bengal rose, or an orange red like vermilion or Winsor red, this will influence your choice of blue. In turn, these two colours help you to decide which yellow to add to your blue and red. Plan your choices before you start to paint and visualise the finished result you hope for.

Painting plenty of colour patches on a scrap canvas is a good start to any picture you may wish to work on. In doing this you may find a whole gamut of colours you have never used before, or realise that very few colours will produce all the tints you need. As you gain experience you will develop a preference for certain groups of colours, as in music a composer will often have a favourite key. As time goes by, people often have a few favourite colours which suit their subject matter and which can make their work highly personal and individual. The possibilities for your

TRANSPARENCY

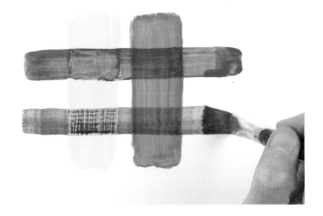

1 Because of the way pigments are carried in polymer acrylic gel, these paints can show wonderful clear transparency on a white surface. This colour patch shows the colour well watered down. Lay alongside the first stroke a stronger wash of the same colour.

2 When the first patches are dry, cross with bands of another colour. The brush's hairs make striations in the colour, which add different textures to each cross stroke. Continue to make these patterns with other colours so that you know the look of different mixtures.

UNDERSTANDING ACRYLIC OPACITY

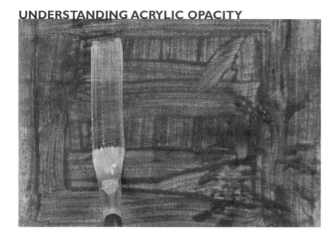

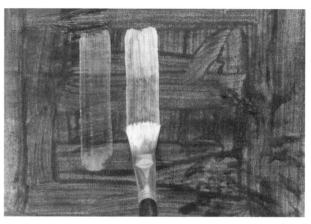

1 Put down a dark background without adding white to your colour. The covering of the ground will be uneven because of the stiffness of the brush and the fact that paint and water do not mix evenly. The full effect will be seen when opaque paints containing white are laid over it.

2 Mix your light paint, this time containing white, and lay a flat stripe. Now add a little more white to the stripe next to it. As the colour patches dry, you will begin to get a feel for how much of the background colour shows through.

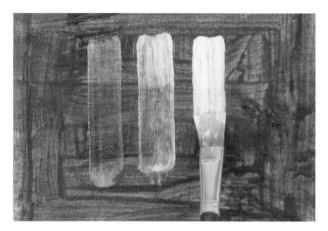

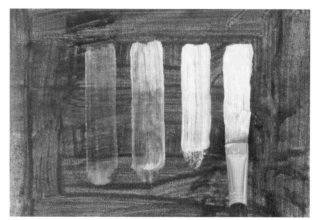

3 Now lay a stripe with a little more white in it. The increased opacity almost hides the textures underneath, but is still being influenced by the background. The point here is that acrylic has a tendency to become more transparent as it dries, giving many unexpected effects.

4 Using these effects to your advantage requires an awareness of the continued presence of textures from the background. Finally, lay a stripe of yellow mixed with enough white to achieve complete opacity, obscuring completely the textured background.

MIXING THE TONAL RANGE

1 Using your paint directly from the tube gives the strongest tint of any colour but as you drag the paint, some lighter tones will show through where the paint is thin. It may take several layers to make the colour solid.

2 Lay stripes with progressively more water mixed with the colour until it diminishes to a point where it disappears. This exercise tells you a lot about how paints behave and how colours have different staining power.

USING A PALETTE KNIFE

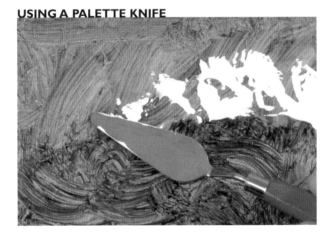

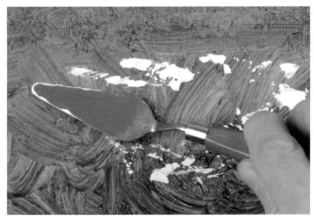

1 Palette knife painting can work well on a light ground, but its most dramatic use is layering light paint on a darker underpainting. Here lots of texture has been left underneath the white paint, in the textured and tinted ground.

2 Much of the fun in palette knife painting is choosing different shaped blades, holding them lightly, and bouncing on the canvas to make repetitions of the blade profile until the paint is all wiped from the blade and the canvas has taken on suggestive shapes.

particular approach to colour are infinite. They will define how you develop as an artist and what sort of artist you eventually become.

colour mixing

When using the colour wheel, make some patches with the colour name indicated on the wheel. This will show exactly how two colours in your palette, made by a particular company and applied on a particular surface, will actually look when you include them in a composition. The colour wheel gives an instant guide to colour combinations and can be used by aligning two colours on the outer rim and checking what colour mix they will give. Alternatively, seek the colour mix you want in the inner windows and then check which named colours are needed to make it. It will not colour match exactly because printing on paper is not the same as paint on canvas, but you can learn the guiding principles of colour mixing from the colour wheel and be able to reproduce them with confidence in your own paintings and sketches.

If you use mixed media, record which makes and colours of felt-tipped pens, inks, and other materials you use, so that you always have some reference to work from.

brushes and knives

Choose your brushes with care, but don't buy too many at first until you know which you like to work with. Round brushes tend to leave ridges in the paint on either side of each stroke. Flat brushes are very versitile as shown on pp. 32–33, and filberts will place paint accurately as well as having good blending and covering capabilities. This general advice holds true for knives, too: do not buy too many to begin with. Get to know how one or two work and add to them as you develop as an artist.

USING DIFFERENT MEDIA

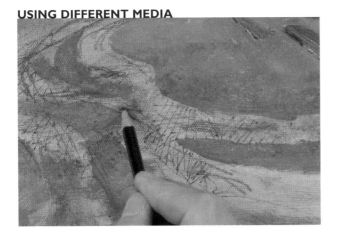

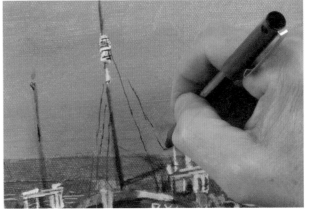

1 Acrylic paint can be augmented by many other media. Here a black crayon is being used to add some small shadow details. Take into account when trying this technique that these marks may be dissolved if you put a varnish over them.

2 Here a felt-tipped pen is being used to add rigging detail. The pigments in these pens vary, so you will have to experiment and find some that adhere to the paint. These work better on areas that contain less white in the paint.

experimentation

The aim of this techniques section is to give as much practical advice as is possible within the format of the book. The instruction manual aspect of this book is designed, like a cookbook, to give you the simple recipes that will help you to achieve your personal artistic satisfaction. Once you have gained all you can by working through the projects, using them to develop your skills and perhaps gaining an insight into the way you would alter the subjects, the most exciting adventures with paint can begin. For it is not until you choose and decide on every aspect of your work for yourself that the artist you are will appear in your work. What makes you want to paint? Is it the desire to capture some aspect of nature, or is it the subject you love, or wish to preserve for future reference? Only you can answer this, of course. But, whatever you are prompted to paint, experiment as much as you can for experiments are often the key to giving new insights into ways of expressing yourself. Keep a sketchbook and take it with you when you are out and about to record what you see. Add colour notes as you work. Never destroy your experiments and test pieces, stick them into a notebook so that you can browse through them at any time. Keep all your colour-matching tests with every colour clearly labelled with the colour name and the manufacturer's name. You can then reproduce exactly a favourite tint used long ago. Without it, colour memory fades like a musical sound.

PREPARING A DARK GROUND

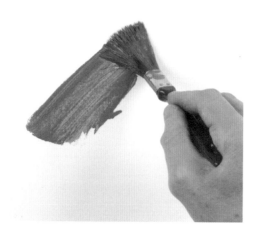

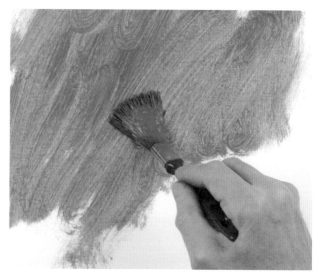

1 Starting with your light white surface, first check that it is as smooth as you wish, as any blemishes will show through to the final picture. Mix up plenty of paint and use a decorator's brush big enough to cover the canvas quickly.

2 Cover the whole canvas as quickly as possible. Your aim is simply to get some paint over the canvas, using a fully loaded brush. At this stage, you cannot have too much paint on your brush. Spread it out to cover all areas.

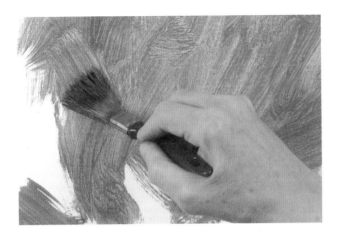

3 Now begin vigorously to spread the paint in all directions, making sure by firm brush pressure that no air bubbles are trapped and there are no areas of canvas grain left uncovered. Don't worry too much about the unevenness of coverage at this stage.

4 With long continuous parallel strokes from edge to edge begin the process of smoothing out the paint to a fairly even tone. This will start to have the effect of eliminating texture as you work.

5 Drag your brush across at right angles to your previous marks so that any lines in the paint cancel out the previous ones. You could leave the surface with this 'woven' texture, if that will suit the painting you have in mind.

6 Turn your canvas and once again draw the brush lightly across as right angles to the previous strokes until you achieve a finish that pleases you. Remember that the texture you decide upon will influence your finished picture.

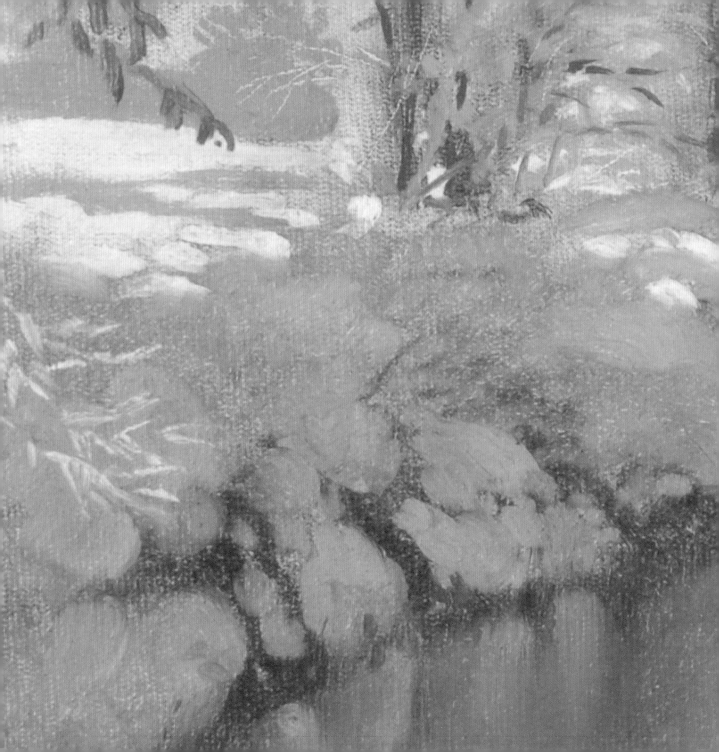

gallery

Acrylics are a wonderfully flexible medium and here you will
see many styles and effects. From tight, meticulous
draughtsmanship to soft free-flowing washes, each artist has
their own vision and approach. Study the paintings carefully –
each one can suggest a starting point for your own work.

**paris from
montmartre**
965 x 1065 mm (38 x 42 in)
mark leach

Starting from a red
background that pervades
the whole painting, the artist
has contrived a combination
of warm and cool colours,
reduced to a simple patches.
They work as an abstract
arrangement yet give enough
clues to those who have
struggled up the long flight
of steps to Montmartre, the
19th-century Mecca of
Parisian artists.

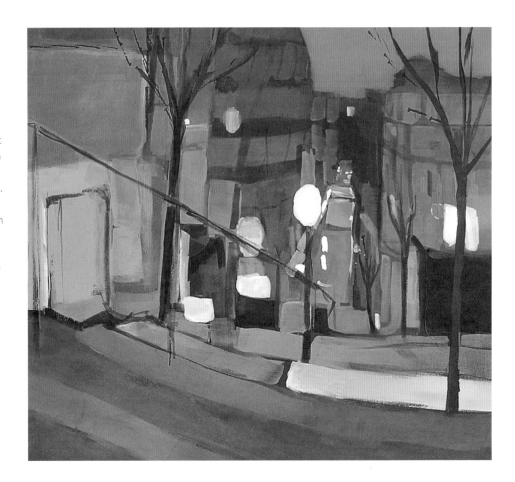

sunlit snow
200 x 250mm (8 x 10in)
john barber

This sunlit snow scene on the banks of a small river follows the impressionist style. The simple composition leaves all the attention on the handling of light. Its narrow colour range is achieved using only two colours, burnt sienna and cobalt blue.

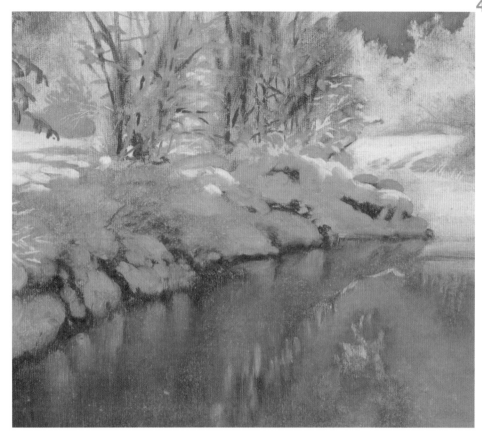

dungeness
150 x 450mm (6 x 18in)
rima bray

This panoramic view captures the strange emptiness of this shingle beach, a geological feature in the south of England. The gentle colours and sparse treatment admirably suit the featureless landscape.

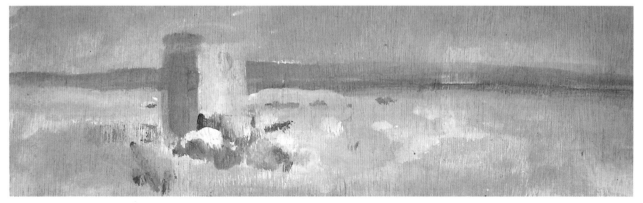

conway estuary, wales
585 x 585 mm (23 x 23 in)
averil gilkes

By the strong receding lines in the foreground in combination with subtle weakening of the colour as it goes towards the horizon, the artist shows us a shimmering scene of colour harmonies and masterly handling of light.

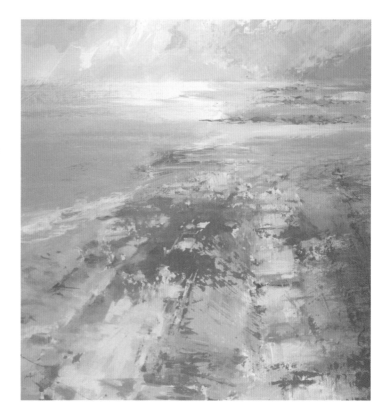

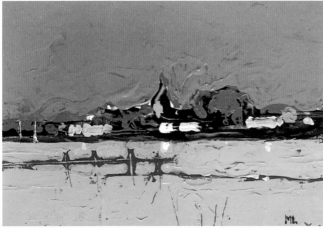

bosham
125 x 175 mm (5 x 7 in)
mark leach

This shows what a small painting by economy of means, thick paint, and blocks of colour can achieve. By almost abstract treatment, a well-designed and evocative wetland scene comes to life without a single superfluous touch.

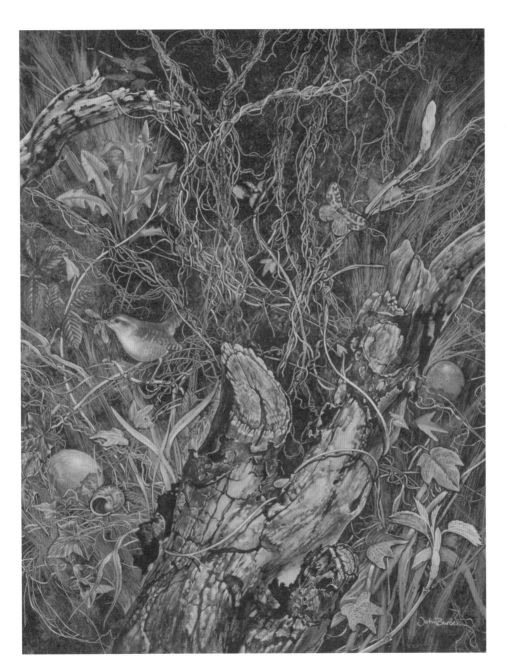

wren in the undergrowth
500 x 350mm (20 x 14in)
john barber

This picture is included to show how the acrylic medium copes with very detailed subject matter. It uses many techniques such as thin washes, scratching through thick paint, and some coloured glazes. Although this took a long time, I have a feeling that I have not quite finished with it yet.

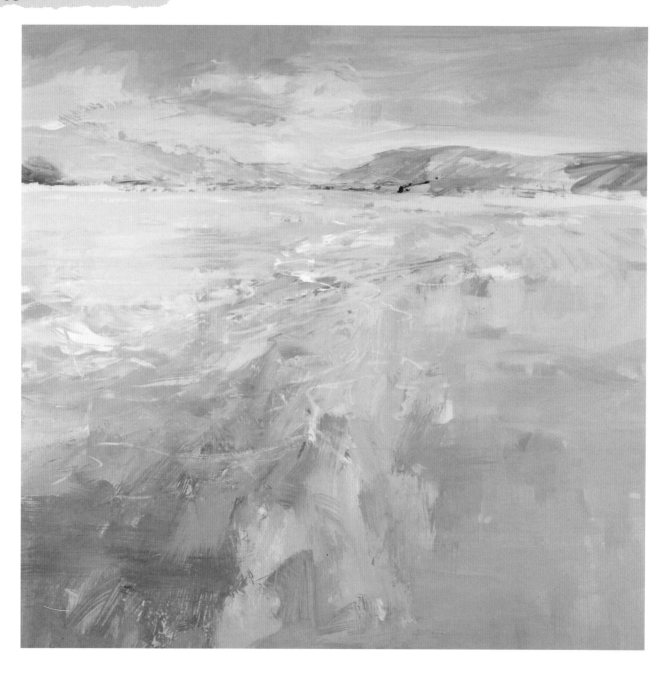

distant light, kilve, somerset
585 x 585mm (21 x 21in)

averil gilkes

Although this coastline scene is nicely balanced between realisation and mystery, it is the glorious colour which makes it so enjoyable. The joy of having so much turquoise in every part of the scene, enhanced by the touches of soft yellow ochre, makes it a picture to dream in.

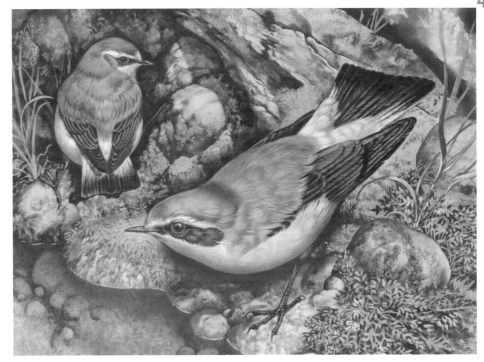

view from the studio
965 x 1065mm (38 x 42in)

mark leach

A sensitive composition of abstract shapes establishes a rare sense of repose. This is the work of a born colourist.

wheatears
225 x 300mm (9 x 12in)

john barber

Detailed work for a book illustration, carried out in almost watercolour technique, with lots of stippling. Thinned down acrylic was used in an airbrush to strengthen the three-dimensional effect in this painting.

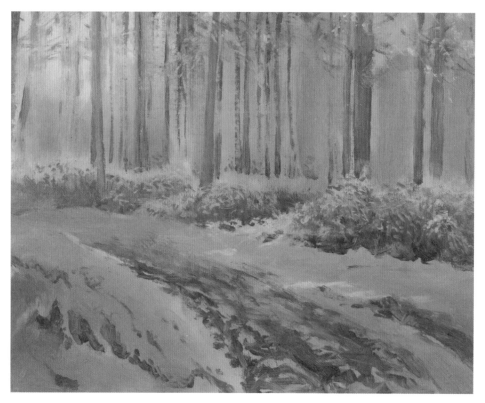

place des vosges
900 x 800mm (36 x 32in)
mark leach

Wonderfully bold abstraction of an avenue of trees, with attractive colour combinations, this picture shows how you can continue to make brave, broad brush changes throughout the course of an acrylic painting.

st mary in the marsh
100 x 150mm (4 x 6in)
mark leach

The dramatic effect of a church tower isolated in the flat marshland gives a focal point for a treatment of sky and trees. The piled up detail of thick paint in the foreground acts as a counter to the red sky.

woodland light
350 x 450mm (14 x 18in)
john barber

Painted on a very cold day, in a Wiltshire wood, this painting demonstrates the value of a limited palette of raw umber and yellow ochre and the wonderful variety obtained from ultramarine.

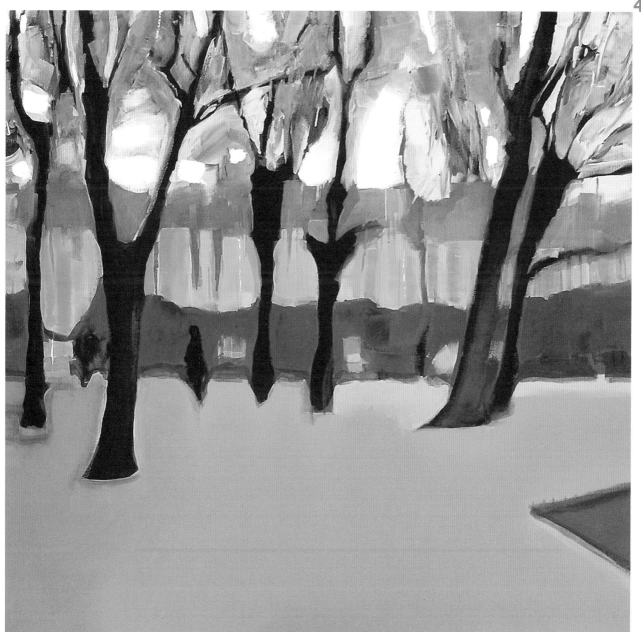

the projects

Being able to capture the essence of a scene is the skill
all artists seek to master. These projects take you step-by-step
through a wide range of different subjects, from still lifes to
landscapes, using a range of techniques that will help you
develop your talent as an artist.

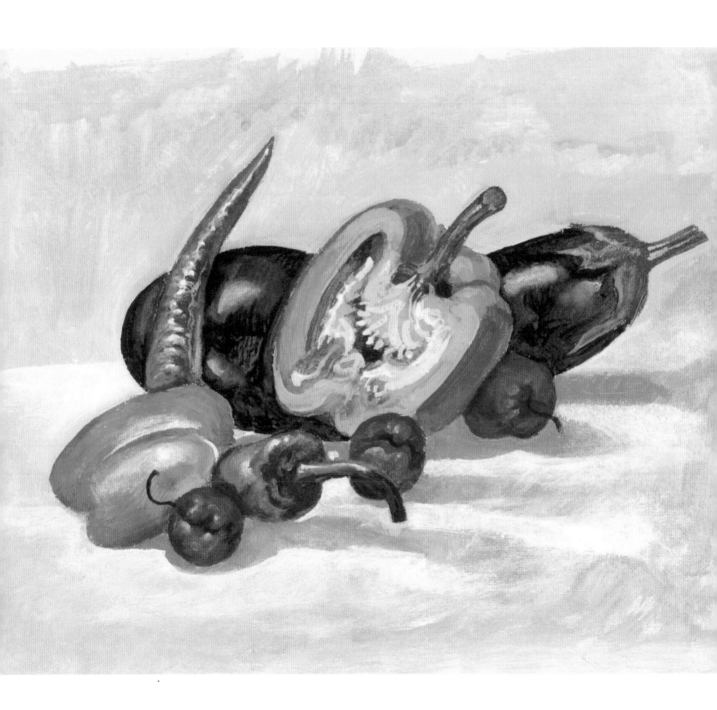

1

eggplant with peppers

john barber

240 x 340mm (9½ x 13½in)

Rounded, overlapping shapes, balanced by one or two profiled stems with strong contrasting colours, are enough subject matter for a still life study. If you only have a few vegetables on hand when planning your picture, slice one or more to reveal the inner surfaces and add interest and texture. Strong directional lighting will make your painting more dramatic and will show the pattern of light and shade more clearly. If you light your composition with a desk lamp, try out several angles until your still life is lit with a balance of light and cast shadows that pleases you. Arranging and painting still life subjects will teach you a great deal about balance and composition and also develop your confidence as an artist.

TECHNIQUES FOR THE PROJECT

Creating highlights

Arranging objects

Glazing

WHAT YOU WILL NEED

Canvas board
Black chalk
Brushes: flat hoghairs nos 2, 4, 7, 8, and 10; round sables nos 2 and 6

COLOUR MIXES

1 **Payne's gray**
3 **Burnt sienna**
4 **Yellow ochre**
5 **Cadmium lemon**
6 **Cadmium yellow**
7 **Orange**
8 **Cadmium red**
10 **Violet**
12 **Ultramarine**

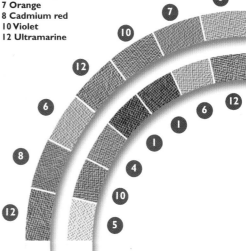

MODELLING FORM

The technique of modelling form to suggest a third dimension is so universal in representative painting that it is almost a cliché, but the elements of middle tone, shadow, highlight, back lighting and cast shadow are essential to such a variety of painting styles and subjects that it was used by every artist until the invention of photography. Chiaroscuro, the depiction of light and dark by shading, is the convention by which most people readily recognise objects in pictures. Brought to technical perfection, along with perspective, in the 16th century, it solved all the problems of depicting objects in space. It is not dependent on colour. A green or red cow, painted in the correct tones of light and shade, would still be a recognisable cow. In preparation for tackling the still life project, go through the stages of painting a simple sphere in three dimensions. The first thing to decide in any scheme of light and shade is the position, imagined or real, of the light source. This must be checked throughout the painting. A simple device is to draw an arrow in pencil near the top of the picture to show where the light is coming from. The second is to establish the exact shape of the object and paint it in the middle tone. No amount of skill in shading will correct inaccurate drawing or make it convincing, but a correct silhouette will often save a badly modelled subject.

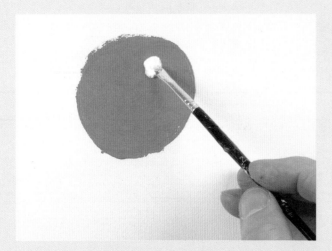

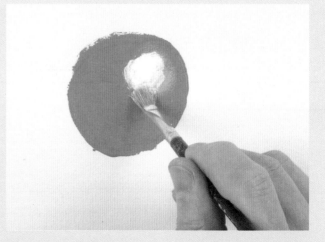

1 First put down a roughly circular disk of colour for your fruit. This will remain your base colour and much of it will remain untouched after this stage. Using a small, flat hoghair brush, place a spot of almost white paint at the top right.

2 Now with a larger, flat hoghair brush, which is slightly wet, work around the outside edges of your highlight, gradually making it bigger, but do not touch the centre of the spot. Blend smoothly, keeping the surface damp.

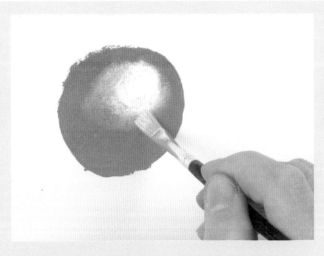

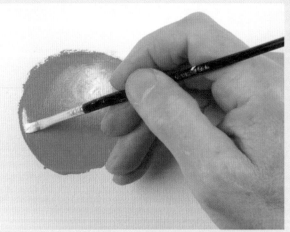

3 Gradually fade out the edge of the highlight by applying more water to your brush and blending the highlight away to nothing. Use a circling stroke for this so that the brushstrokes do not appear 'stripey'. Keep the light area away from the top edge.

4 Having painted the flat disk into the illusion of a sphere, you can now take your smallest hoghair brush and, opposite the source of light, which in this case, is coming from the top right, paint a curved line using your highlight colour.

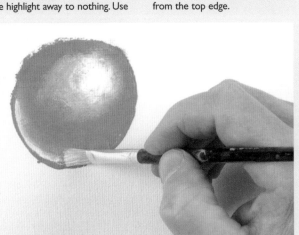

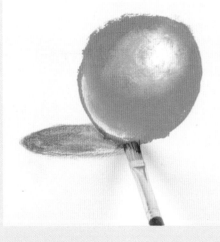

5 With a slightly larger brush, again dipped in water, blend the upper edge of the line into the dark background colour. Do not let this band of colour get too wide, as it will spoil the apparent roundness. If this does happen, wipe it out and start again.

6 Using Payne's gray and ultramarine, paint an oval on the left-hand side, making it darkest underneath the fruit. This will make the back-lit edge more effective. Observing where back lighting occurs will improve your painting.

1
eggplant with peppers

Arrange your composition and sketch out the main lines in chalk. Look at the shapes of the objects and the relationship between them. Look at how the objects cut into one another and the shapes of the gaps between them to help you to draw them accurately. Once you start to paint, you can adjust the outlines of the vegetables if you find they are not quite right.

BUILDING IMPASTO

Do not be afraid of building up your colour. The thickness of the paint can be part of the attraction of the finished painting. Load your brush and slide it over the canvas without pressing too hard so that the paint is left thick and each brushmark is visible. Learn to value your marks and do not try to hide them.

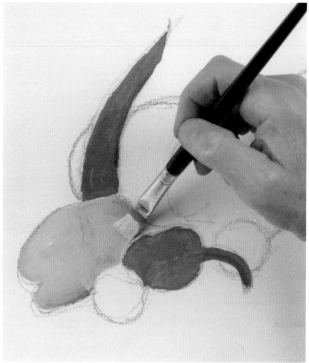

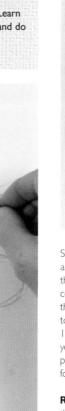

Start by putting a flat colour on all the vegetables. Paint fairly thickly from the start, using the colour more or less straight from the tube, with only enough water to move it. Use the edge of a no. 10 brush and a mix of cadmium yellow and ultramarine for the long pepper. Use pure cadmium yellow for the two yellow peppers.

RIGHT Add some orange to the cadmium yellow to give it a more golden look and use this for the outside of the pepper.

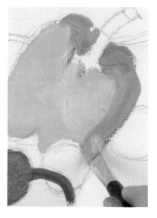

STEP 1 ▶▶

STEP 2 ▶▶

Next paint the small red chilli peppers. Use pure cadmium red for these. Continue to use a large brush, no. 8, to keep plenty of vigour in your work. As you paint the third red chilli, you will have the chance to clean up the profile of the yellow pepper.

SMOOTH CURVES

Try to get smooth curves when you are dealing with natural forms such as these vegetables. Their perfect smoothness and roundness, as well as their rich colours, are part of their appeal. If you are using a large brush to keep some vigour in your marks, use the corner of the brush when making detailed marks.

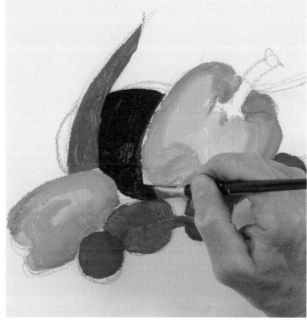

Now mix up the colour for the eggplant, which is going to be violet and Payne's gray. Leave the shape of the leaf covering and stalk at the end of the eggplant. Now draw the yellow pepper more carefully, noting the shapes within it. Go down to a smaller brush, a no. 7. Take some gold and get rid of the blank canvas between the objects.

RIGHT Go down to a no. 4 brush and add some burnt sienna to the green used for the long pepper and add some shadow inside the cut pepper.

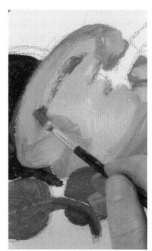

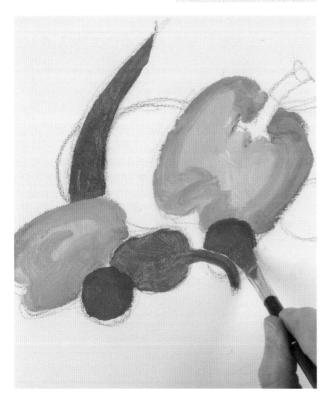

STEP 3 ▶▶

STEP 4 ▶▶

1
eggplant with peppers

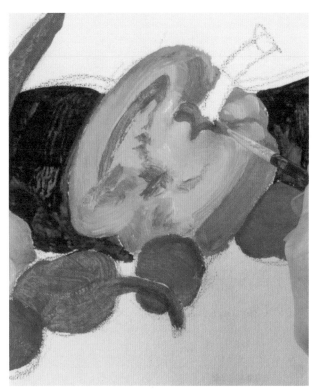

RIGHT Mix some yellow ochre to your green mix and use this to fill in the leaves and stalk of the eggplant.

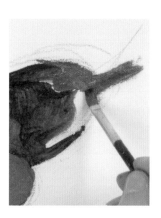

Outline the whole grouping with a mix of Payne's gray, ultramarine and white. This bluish neutral grey will help to establish the clean edges of the shapes, cover up the chalk marks and also give a tone that will be retained as a shadow.

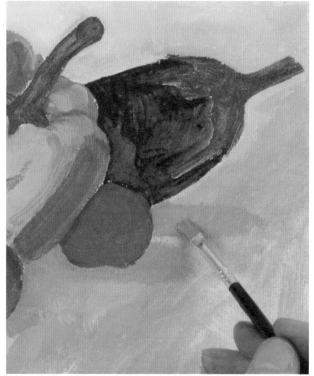

Work inside the cut face of the pepper. Add some red to the mix to get a darker tone, where the pepper is cut. Then build up the shape of the solid, uncut areas around the stalk.

RIGHT Add a little ultramarine to your green mix, and with the no. 4 brush create the shape of the pepper. Add more ultramarine and get some darks into the pepper.

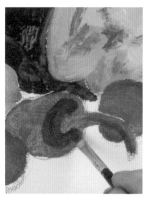

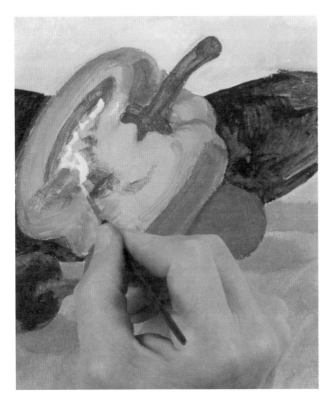

RIGHT Take the yellow you used for the pepper, add some white and a touch of yellow ochre, and use this colour to start to add highlights on the pepper. Drag this on quite dry.

Continue to work inside the pepper, with fairly thick paint. Take some pure cadmium yellow and use this to define the shape of the pepper. There is now a ridge of paint, defining the edge of the pepper against the eggplant.

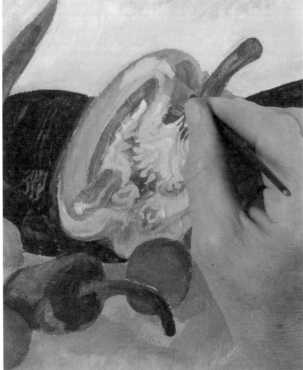

Use your background colour mixed with more ultramarine to create shadows under the forms. Leave some darker tones under the objects. Then, start to work up the lighter area in the centre of the pepper. Add white to your cadmium yellow for this.

A NEUTRAL GROUND

With a subject such as this one, it is vital to cover the canvas around and between all the objects, in this case using a neutral grey tone. The reason for doing this is that with this subject, there will be glossy highlights. If there were canvas still showing, that would detract from the glossy highlights.

STEP 7 ▸▸

STEP 8 ▸▸

1
eggplant with peppers

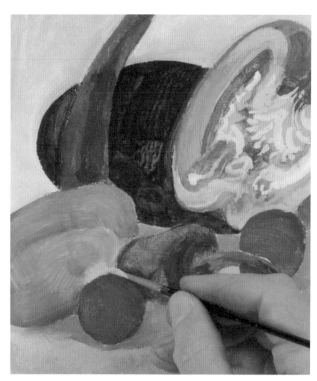

RIGHT Now start to work on some of the highlights to give the painting its sparkle. Use your green mix with a touch of white and yellow ochre, and add some highlights to the eggplant. Use the same mix to outline highlights on the leaves. Rub these with a hog brush to blend.

Mix a brighter green using ultramarine and cadmium lemon, with white added and use this to work some modelling onto the stalk of the pepper.

Add highlights to the uncut pepper, building up the shape of the pepper. The soft brush drags colour into paint that is already dry. Lift the area of eggplant where it is picking up colour from the pepper, with a redder mix.

RIGHT Indicate more modelling on the red chillis. Mix a touch of violet into cadmium red, for a darker red. Do not make this too stiff: it needs to be fairly runny.

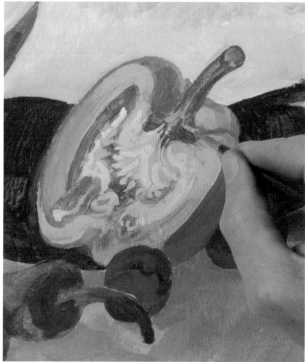

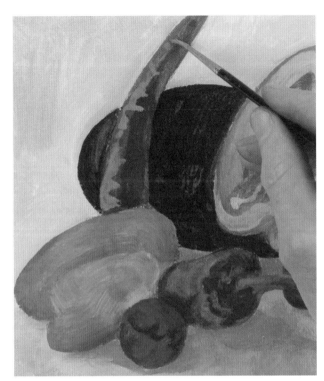

RIGHT Then start to blend the soft edges of the white highlights.

Work around your painting, picking out the highlights on all the vegetables in turn. When you have completed the eggplant, work the highlights and blend the red chillis, then the green chilli. Then, make the central area of the cut pepper a little brighter.

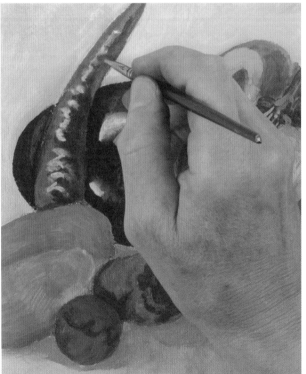

Use the same mix to add highlights to the green pepper. Don't be too quick to blend all your marks. If a mark looks right, leave it as it is, without blending.

RIGHT Take a small sable brush no. 2, and a second sable no. 6 to blend with, and start to add touches of white. Squeeze out some pure titanium white. Look carefully to see the shapes of the highlights and add them as shapes. Don't make the highlights bigger than they are.

STEP 11 ▶▶

STEP 12 ▶▶

1
eggplant with peppers

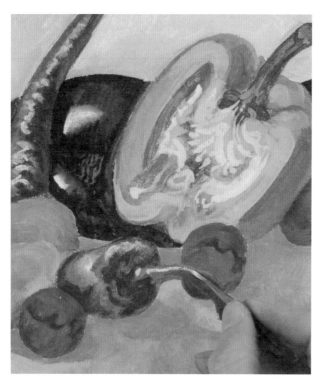

Glaze the peppers with the washy mix of cadmium red again. The stem of the red pepper has not been worked, so add some green here. Then, work the detail in the cut face of the pepper, re-establishing the drawing here.

GLAZING HIGHLIGHTS

Highlights are difficult to get right first time. It is easy to make them too white which fragments the colour scheme and looks unnatural. Blending in often softens the highlight but weakens the effect by spreading it too far. With acrylics, it is easy to glaze a highlight after it is dry.

Now start to glaze over the highlights with their underlying colour, so that the highlights are not too stark. Use a very clear colour: this will prevent the highlights from appearing too chalky. Take a soft sable brush and paint the glaze over the highlight.

RIGHT Mix a thin wash of cadmium red and use this over the highlights on the chilli peppers. If this tones them down too much, add more white.

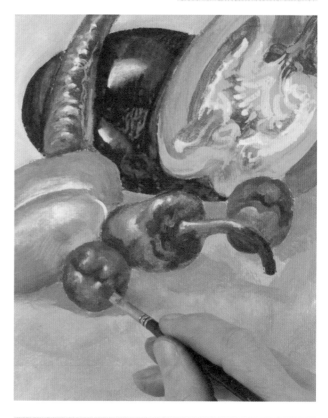

STEP 13 ▶▶

STEP 14 ▶▶

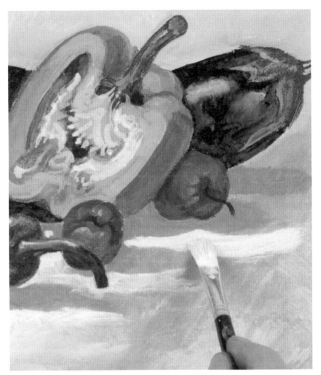

Finally take some violet and tone down the highlights on the eggplant. Although the highlights on the eggplant are glossy, these are looking too white.

HAVE I FINISHED?

During the painting process pause frequently and look at what you have painted. You will soon learn what degree of finish you prefer or whether you like rather abstract suggestions about the subject matter. Ask yourself "Do I like it now?" If the answer is yes, then for you the picture is finished.

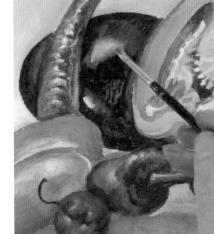

Take some white and a fairly small hog brush and use it to lighten the foreground. Use a no. 7 for lightening, and a no. 2 to define areas.

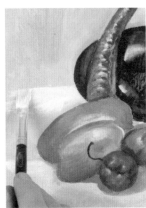

RIGHT Add a touch of yellow ochre to the white so that it is not too stark and start to create areas of light and shadow. Blend the edges of the area so as not to get a hard edge.

STEP 15

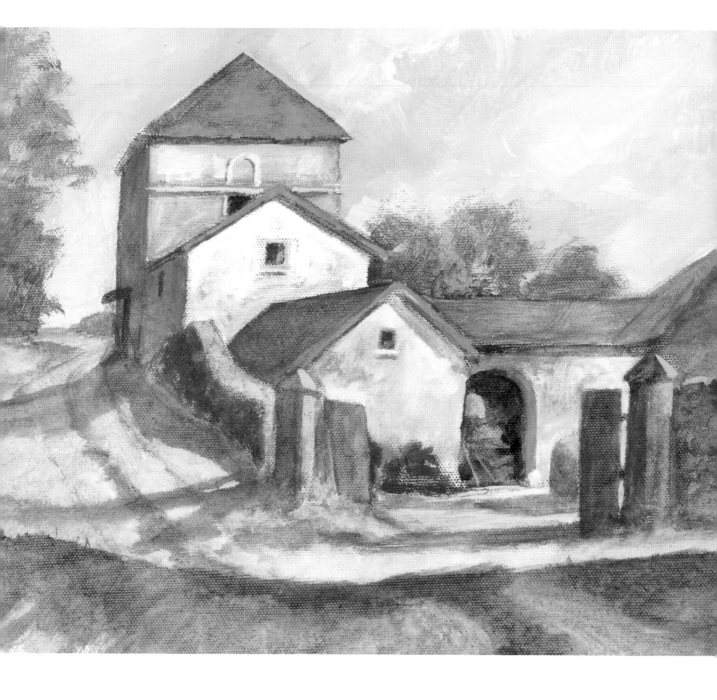

2

french farm buildings

john barber

240 x 310mm (9½ x 12¼ in)

This project takes as its subject some old farm buildings grouped around a yard. The buildings in the grounds of the chateau at Rochebrunne in France are simple boxes with slanting roofs and small windows. There is no decoration or detail, just an arrangement of light and shadow. The repeated inverted 'Vs' of the roofs are the main subject and the whole is anchored in the rectangle of the picture by the horizontal shadows and the roof on the right. Since even a thick coat of acrylic paint will dry during one painting session, you will be able to drag colour across the lighter surfaces to suggest the broken textures of rendering and stone and signs of age which make ancient buildings so attractive to the painter.

TECHNIQUES FOR THE PROJECT

Drawing perspective

Texturing and scumbling

Glazing shadows

WHAT YOU WILL NEED

Coarse-textured canvas board
Black chalk
Brushes: flat hoghairs nos 2, 5, 6, and 10; round sable no. 2
Mahl stick

COLOUR MIXES

1 Payne's gray
2 Viridian
3 Burnt sienna
4 Yellow ochre
6 Cadmium lemon
8 Cadmium red
10 Violet
12 Ultramarine

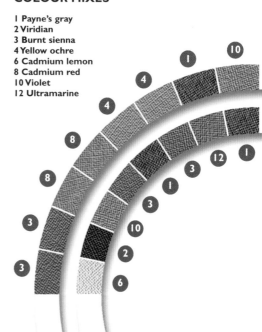

DETAILING BUILDINGS

The representation of buildings in your pictures is an important part of the techniques of landscape painting. If you can render a building or, more often, only a small part of one convincingly, then it will give your work a sense of scale and reality. The building should be painted more carefully than any other part of the picture because it is more difficult and it is the first thing that someone looking at a landscape will notice. Many amateur paintings are spoiled by the prominence of the buildings and the attempt to include too many details at a scale that their skill cannot cope with. When painting a landscape, they are often confused and unsure how to render masses of green trees, bushes, and fields, but once they spot a building their knowledge of what is there over-rules what they can actually see. Although the buildings in a landscape may be tiny, these painters put in glazing bars and windowsills that are so difficult to do at that scale that even Canaletto (1697–1768) would have avoided them. It is far better to keep the small dark marks that you can actually see. Buildings are basically boxes with holes in them, and a good exercise is to arrange a few plain cardboard boxes on a table top, and paint or draw them as simple shapes, noting the light and dark areas and cast shadows. You could even cut a few openings for doors and windows.

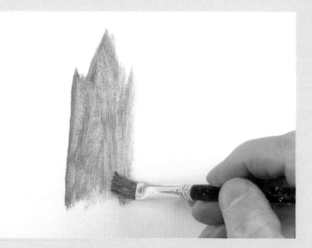

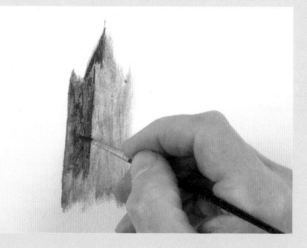

1 In neutral tones, establish a simple shape for the building using a medium flat hoghair brush. Use the flat edge of the brush to draw the straight edges. Hold the brush fairly upright to do this and pull the brush toward you.

2 Now take a small sable or soft hair brush and start to paint in the flat darker shapes that are in shadow. Adding in these darker areas immediately establishes for the viewer the direction from which the light is falling.

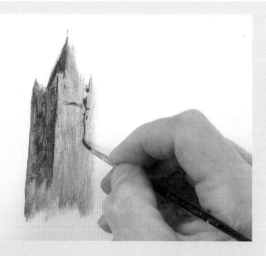

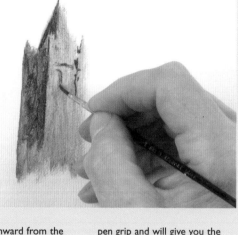

3 Begin to paint some detail on the light side of the building. The dark lines represent cast shadows so you will need to remember where the light is coming from. You only indicate shadows on the top and right-hand side of any feature.

4 Work downward from the top of the building and hold your sable brush down near to the ferrule. This is more like a pen grip and will give you the control you will need when you want to make a series of small neat marks.

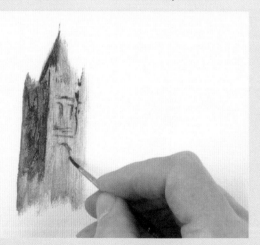

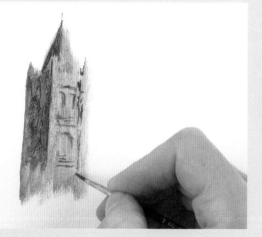

5 The tricky part of detailing buildings is drawing several shapes to look identical. Practice repetition of marks on scrap paper or the edge of your sketch. Your picture will work better if you ignore detail on the shadow side of the building.

6 In this exercise you will have gained experience in making controlled marks on a flat area. Try to paint with quick, flicking marks rather than going over them more than once. This is not easy so keep practising to improve your skills.

Draw the main lines of the composition using chalk. Concentrate on the large simple shapes of the rooftops, and the relationships between them and the relationship between the roofs and the walls. Indicate where the shadows will fall by rubbing the chalk in with your finger to create dark patches. You are going to start your painting with the sky, which should be kept fairly light. Mix some violet, white and Payne's gray, with a little ultramarine.

SHADOW AREAS

In this composition the shadow areas are going to be important, so they need to be planned and drawn in fairly accurately. Here a wash of Payne's gray and ultramarine, with no white added, allows this accurate drawing of shadows in order to fix the dark tones of the composition.

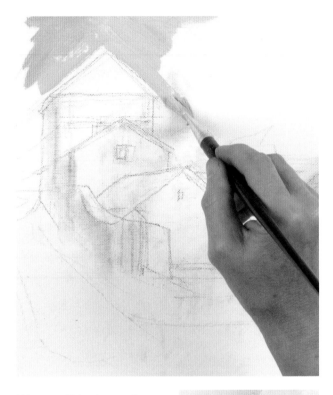

Using a no. 10 brush, cover the sky area with this fairly strong mix to get rid of the lightness of the canvas. This starts to cut out the shapes of the buildings. Use the edge of the flat brush as a drawing instrument. Introduce more white into the sky colour, for the clouds. Blend this in.

RIGHT With a wash of Payne's gray and ultramarine, and a no. 6 brush, start on the shadows. Use the edge of the brush for the straight lines.

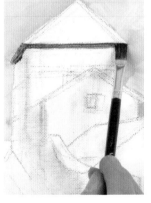

STEP 1 ▶▶

STEP 2 ▶▶

Steady your hand on a mahl stick to help you to paint in these areas accurately. Work down the edge of the building, and add the gatepost. Indicate windows in all the buildings. Next, work on the shadows that are being cast on the path and grass. At this stage, note that the shadow that is being cast is darker than the object that is casting it. The gatepost is casting a shadow onto the path.

TRICK OF THE TRADE

It is a good idea to leave yourself one or two compositional notes as you work. You may or may not need them, but if you do, they are in place. In this painting, a compositional note was left in the archway and was picked up later to help the overall effect: the shape could be a farm cart or old machinery.

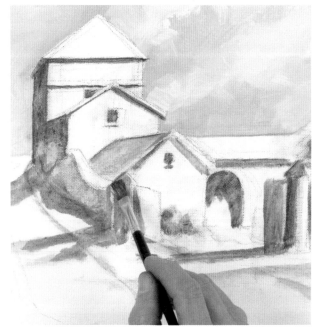

Leave part of the doorway white, then work a deep shadow along the barn roof. There is now a monochromatic image of light and shade in the picture. Next, establish the colour of the buildings: mix yellow ochre with a touch of burnt sienna for those that are in the light. The paint is picking up some chalk, which is modifying its texture slightly. These variations are in keeping with old farm buildings.

RIGHT Now rub a thin wash of burnt sienna into the roofs, starting at the top and working down and across your painting.

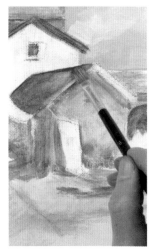

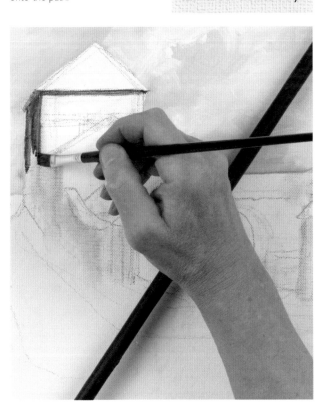

STEP 3 ▶▶

STEP 4 ▶▶

2
french farm buildings

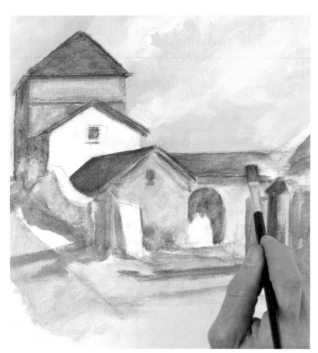

RIGHT Add a touch of burnt sienna to viridian to modify it down from a tropical green. Also add some yellow ochre to this colour mix, to create a second green. Work these into the foliage. Then, add some cadmium lemon to modify this some more.

Start to indicate the trees on the right-hand side. With the brush flat, rub your tree colour into the sky to give some blurred shapes where the trees cut into the sky on the left. Use the side of the brush to cut the trees into the sky.

Mix cadmium red and burnt sienna and keeping the wash thin, use it to strengthen the colour on some of the roofs.

RIGHT The next stage is to get some colour onto the building on the left with the white end. This is a mix of burnt sienna and Payne's gray. Add a little more cadmium red, toned down with violet, to create the pink colour of the door. Use the same colour for the other door, but since this is in shadow, and so painted over the grey tone, the colour is modified.

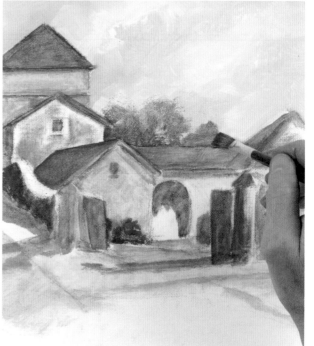

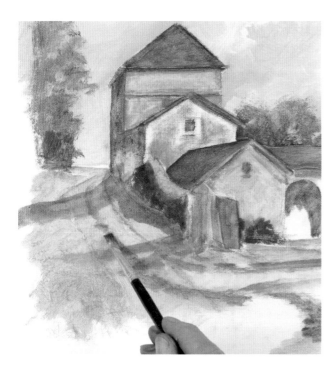

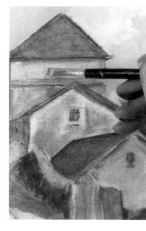

RIGHT Using a mix of white and yellow ochre, start to look at the tone of the buildings and begin to work with thicker colour. Use this colour mix all over the buildings, gradually building up colour, making it more solid.

Cut out the arch more clearly. Work around the door, then add more white to the mix to indicate the gap between the gatepost and the door.

Next, paint all the areas of grass including the shadows. This gives areas of light and shade, without losing the basic shapes created in monochrome. Use this same colour to indicate the curve on the path in the foreground. This line will lead the eye into the composition. Now start to build up areas of solid colour. The trees that can be seen in the distance are going up a hill. This is important to get a sense of distance into the composition.

CHOOSING WHITES

You have the choice of several whites to use in your work. Decorator's white is good for covering canvas or board, to give you a background tint on which to work. Titanium white is pure colour and offers the best opacity. The colour that is labelled 'mixing white' flows more easily but is less opaque.

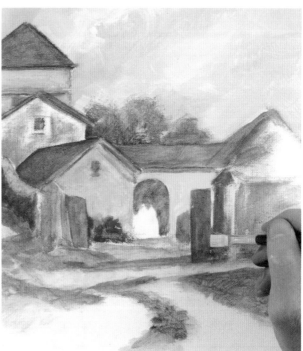

STEP 7 ▸▸

STEP 8 ▸▸

2
french farm buildings

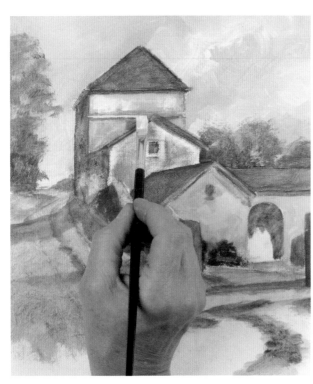

RIGHT Add some Payne's gray and burnt sienna to your white and yellow ochre mix and use this to tone down the end of the building on the right. Rub a little texture into the building.

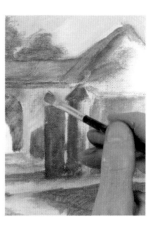

Get a little opaque colour into the shadow. This helps to solidify the buildings so that they do not appear as unrelated shapes.

Go back to the tallest building and make it lighter and also indicate the ridge of stonework that sits across it.

RIGHT Make the end wall lighter and more uniform in colour. Continue to build up colour, improving the shape of the window a little.

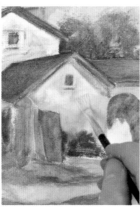

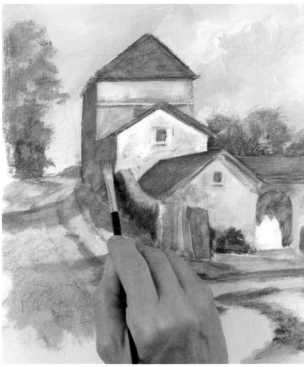

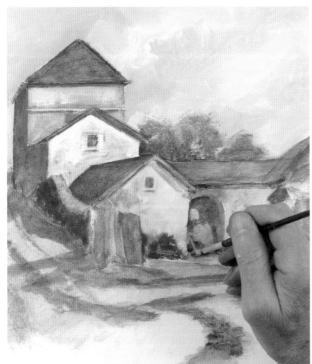

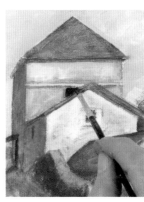

RIGHT There is a window to the side of the building on the left, so add this. Then darken the window in the centre. All the shadows in the windows are worked in solid Payne's gray.

Use the same colour to create the shadows in the archway. Then mix Payne's gray and burnt sienna to make a strong shadow across the centre of the painting. All the large and small areas of shadow have now been re-defined.

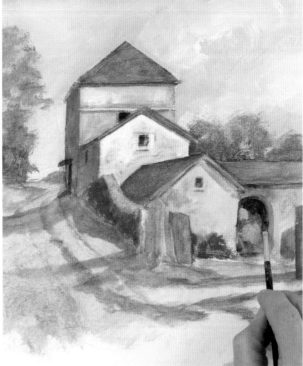

Now turn to the arch. There may be an indication of an old farm cart here, so work this in Payne's gray to begin with. Darken the shadow cast by the roof of the building with the arch. Work around the arch to give greater definition to the cart. The roof of the main building is not symmetrical, so improve this by overpainting with your sky colour.

RIGHT Draw the porch on the right angle, using your shadow colour. Then work the doorway.

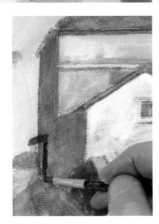

STEP 11 ▸▸

STEP 12 ▸▸

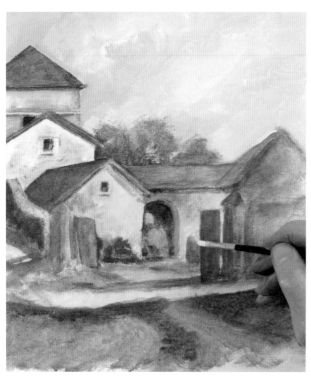

Indicate a stone to help to define the archway and some broken plaster above the gate. The end of the building needs to be even lighter. Then redden the gate. Add some cadmium red and burnt sienna, with a little cadmium yellow to the white and work down the roof using a no. 2 brush. Use the same colour on the left-hand side of the closest roof.

BACKGROUND COLOUR

In many compositions the underlying colour of the canvas continues to play an important part, and sometimes you want blank canvas to show through. Avoid this in areas of shadow, however. It is far less critical in areas of light where it may contribute to the highlights.

Take a no. 2 hoghair brush, and indicate some light coming round behind the gatepost, and paint some lights on the path. Continue looking and building up areas of highlight. Define the edge of the gate, and the foliage next to it.

RIGHT Now sharpen up some of the solid colours, including the windows. Note that there is a light in the stonework above the ridge on the tallest building. Add lighter colour to the sills and under the roof of the filled-in arch.

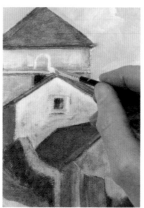

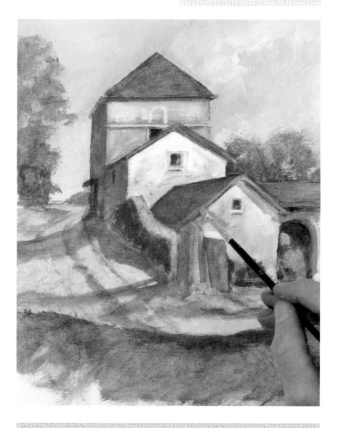

STEP 13 ▶▶

STEP 14 ▶▶

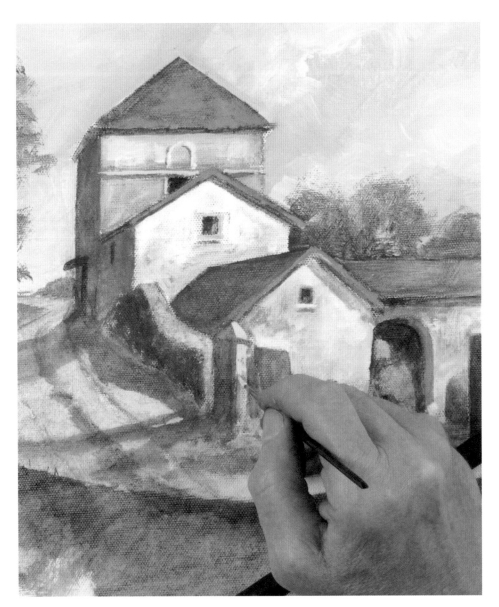

MAHL STICK

It is useful to have a straight edge or rule to lean on to steady your hand. Artists use a mahl stick, especially on larger pieces of work. This stick has padded ends so that the stick itself does not touch the canvas or board and any existing paint is not disturbed. A mahl stick is being used in the photograph on the left.

LEFT Add a highlight coming down the gatepost. Then add a touch of green to the archway and tone down the area beneath the tree on the left. Work one or two marks into the shape in the archway. This needs to be unfocused, so don't overdo it.

Finally work one or two highlights into the yard floor.

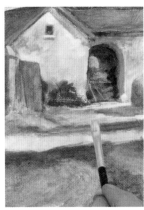

STEP 15 ▶▶ **STEP 16**

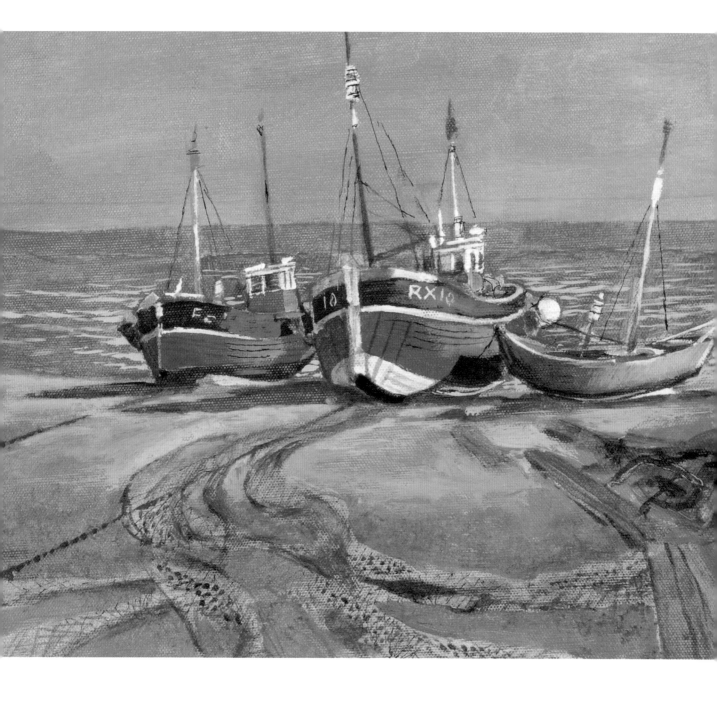

3
fishing boats
john barber
270 x 340 mm (10½ x 13½ in)

Boats have always appealed to artists as subject matter. Their large simple shapes have evolved to function so well in the water that they have a visual attraction whether in the water or out. Here are three English fishing boats pulled up on the beach with their nets spread out in the foreground. Their curved lines flow and interlock leading the eye around and making them into a single motif. In this project, concentrate on the shapes without detailing the working parts. There are many ways of using boats as part of a pictorial design and they do lend themselves to an abstract treatment, but you may develop the taste for accurate rendering of sails and rigging. If you do, this project shows you the basic techniques.

TECHNIQUES FOR THE PROJECT

Planning large shapes

Drawing straight lines

Using dry brush

WHAT YOU WILL NEED

Canvas board
Graphite pencil, 4B
Brushes: flat hoghairs nos 4, 6, 7, and 11; round sable no. 2
Mahl stick
Pen and ink

COLOUR MIXES

1 Payne's gray
3 Burnt sienna
4 Yellow ochre
6 Cadmium yellow
8 Cadmium red
9 Permanent rose
12 Ultramarine

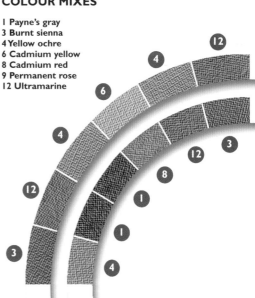

DRY BRUSH

The essence of the exercises on this page is the use of paint that is straight from the tube, applied on a fairly coarse canvas so that the semi-dry state of the paint when it leaves the brush causes it to break up into small dots as it touches the raised part of the weave on the canvas. Whatever your subject, the exercises, which are simplified in these diagrams are vitally important to your development as a painter. Perhaps the thing that distinguishes one painter from another is their 'touch', that is, the way the paint is handled and the sensitivity in the actual stroking of the brush on the surface of the picture. In this way, no two painters are exactly alike and in

developing your own preferences for the kind of surface you like to paint on, the brushes you choose, and the way you mix the paints will express your own unique approach. The diagrams for the exercise give you a chance to explore your reactions to the way the paint behaves. Do these exercises many times, until you begin to feel the different results under your control. Before you tackle the project, make a sketch to try out the textures you wish to use. Tell yourself that it is only a sketch and it may well turn out better than a finished picture. The amateur is often less inhibited by formal training and so often produces unexpected, spontaneous, and visually exciting work.

1 Make a medium-toned patch of flat colour and let it dry. It need not be square as long as it is large enough for you to carry out the exercise. Any colour you prefer will do as long as the tone is right. Load a small flat brush with stiff, light-coloured paint.

2 Holding the brush lightly toward the tapering part of the handle, drag it quickly across the canvas. The aim is to make broken parallel lines with the semi-dry paint. Do this several times without adding paint to the brush until you get the feel of it.

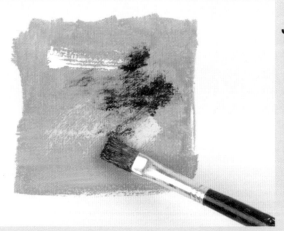

3 With the same light hold on the brush handle, and a slightly darker toned paint, keep the side of the bristles flat on the surface. Swish it from side to side like a windshield wiper, leaving many fine spots of paint on the canvas texture.

4 Now experiment with dark paint on the mid tone of the background. You could start a new patch to work on, if you prefer. This time push the brush away from you as you paint so that the bristles bend back and flick on tiny paint marks.

5 Build up your random strokes until your dark paint becomes a solid patch. Push the brush like a miniature broom and leave the edges fuzzy. This will help your understanding of dry on dry brushwork, as opposed to wet blending.

6 When your dark patch has dried, load your brush with white paint so that you have a large blob on one side of the bristles. Lower the brush. As you move the brush sideways, feel the drag on the paint as it makes ragged broken marks.

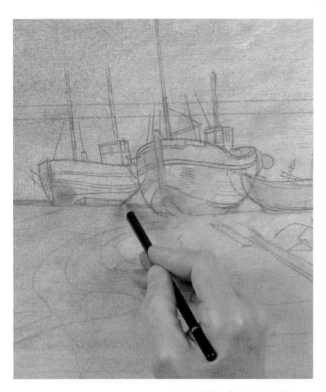

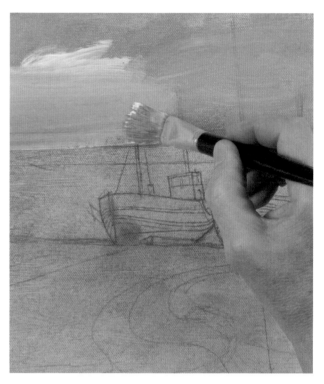

Begin by carefully drawing some boats. Use a 4B pencil to draw the lines of the boats accurately: these lines are an important part of the composition. Get rhythmic lines running through the boats. Having established the composition, look at the horizon and draw that in. The next thing to do is put in a tone for the sky, so mix up some ultramarine and burnt sienna, with plenty of white.

TINTED GROUNDS

Working on a tinted ground establishes the tone of your composition from the start. In this case, the canvas board was tinted with a mix of ultramarine and burnt sienna, and allowed to dry before work commenced. The colour mix for the sky consisted of the same two colours, with white added, to pick up this underlying tone.

Paint the sky using the no. 11 brush. Use the colour fairly thick and bring it down to create a reasonably straight skyline with hills in the distance.

RIGHT Now add some Payne's gray to the mix, to get a grey for the headland in the distance. Bring the grey-green colour of the sea behind the boats. Use a no. 7 brush and mix some yellow ochre, ultramarine, and Payne's gray, with a touch of cadmium lemon for a grey-green, fairly dull colour.

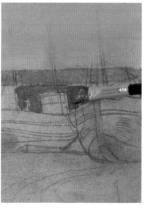

STEP 1 ▸▸

STEP 2 ▸▸

RIGHT There will be flicks of sky blue added to the sea later. Work around the boats to get the background colour sorted. Leave the details for later. Use the corner of the brush to get into angles. Work around the masts, so that you can still see your pencil drawing lines.

Mix cadmium red and a little cadmium yellow to a slightly brick red colour, and start on the boats. Use the paint mix full strength for a solid colour. Use Payne's gray for the tops of the boats.

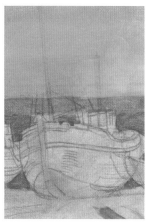

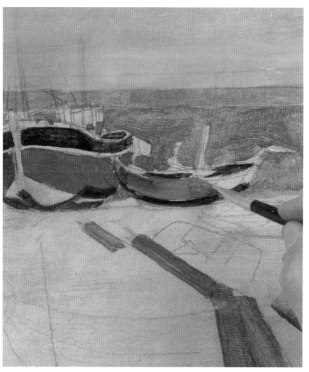

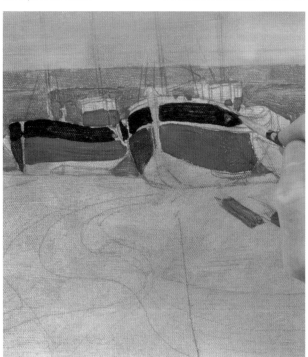

Choose a slightly smaller brush for more detailed areas. Take a no. 6 and mix yellow ochre and Payne's gray for the hull of the smallest of the three boats. This appears to be unpainted. Blend the colour slightly into the dark paint while it is still wet.

BALANCING TONES

In a project like this with a narrow range of greys, the use of Payne's gray helps to get dark tones quickly. It contains black for toning down colours and its blue content prevents harshness, but if overused it can dull your colours. When you come to paint from nature, you should mix your neutrals from a wider range of colours.

STEP 3 ▶▶

STEP 4 ▶▶

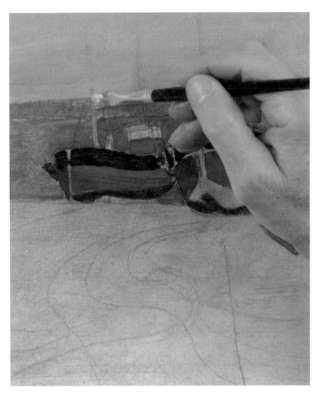

RIGHT Use the flat edge of the no. 4 brush for linework. Line the sides and tops of the boats, then paint the battens on the hulls.

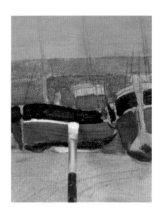

Paint the cabins and other white details such as the masts and float. Put in an indication of the ropes on deck. At this stage these just register as areas of light.

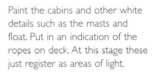

Add some white to your colour mix, and use it for one or two details on the other boats, where there are lighter marks. Work around the canvas, looking for areas of light and add them in.

RIGHT Pull the white down in parallel lines to indicate the shape of the hull. Add some yellow ochre for the support for the boat, then go back to a smaller brush and use white for details.

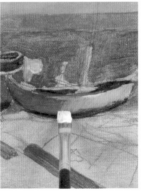

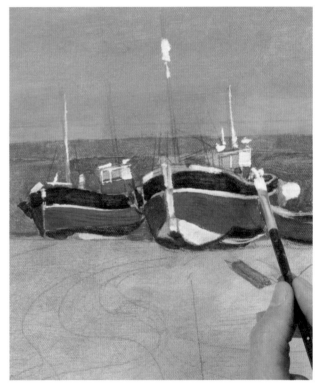

RIGHT Create the white areas of the mast, which will then be refined and detailed.

Work the darks on the masts using Payne's gray to ghost them in at this stage, then put the windows into the cabin. Use a mahl stick to keep your hand off the canvas. Work the windows on the cabin of the left-hand boat. Add the reinforcing battens on the hull.

There are bright areas on all the boats. Define the right-hand side of the central boat, blending the colour in. This starts to get some modelling into the boats. Mix a little ultramarine and Payne's gray, add a touch of white, and use this on the hulls. The colour here is a very dark blue. Light red creates highlights in the deep red hulls, blue-grey creates highlights in the black areas of the hulls.

RHYTHMIC MARKS

When you have a colour paint on your brush, it can give your painting and brushstrokes more rhythm if you use one colour in most of the areas in which it will be needed, at least initially. The dynamism of this painting was helped by adding white touches across the canvas in quick succession. This established all the lightest tones.

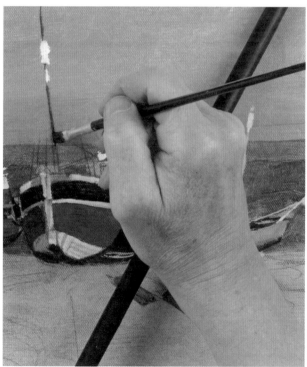

STEP 7 ▶▶

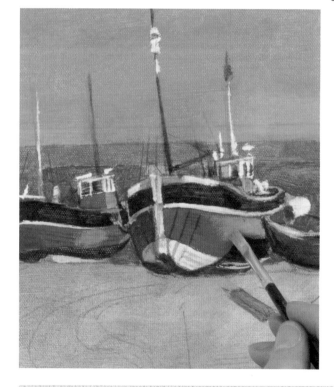

STEP 8 ▶▶

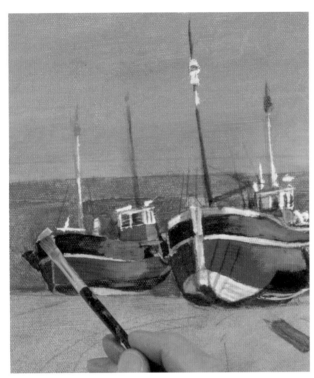

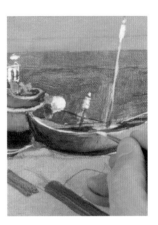

RIGHT Work the mechanism on the right-hand boat. (This might be used to haul up lobster pots.) Use white paint for this.

While you have white paint on the brush, work some details. Once you can recognise what an object is, leave it. What the mark contributes to the overall painting is more important than creating a painting full of detail.

Now use some yellow ochre to warm some of the whites. Add a touch of Payne's gray and glaze over some of the bright whites to lose some of their chalkiness. Work across the white areas with this colour mix, to warm the white.

RIGHT There are numbers on the sides of the boats. Use a no. 2 pointed sable and pure white, very watery paint. Make the number on the central boat slightly stronger than the rest.

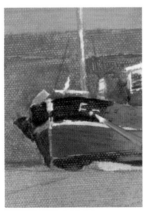

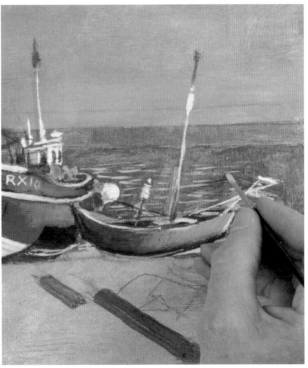

Indicate ripples, since the beach is not flat. Then work a few dark lines on the planking. Add a few more lines on the boats to indicate planks, masts and other fine details using a pen. If you prefer to rule these in, you can, but often on a painting like this one, it works better if the lines are not too fine. If your marks are starting to look too neat, press down with your fingertip to soften them before the ink dries. Use the pen too to get some more detailing on the nets.

POSITIONAL DEVICE

With any painting, you are likely to want to draw your viewer's eye into the work, highlighting the areas that are of most interest. Positional devices allow you to do this. In this painting, the planked boardwalk, and ropes and nets on the beach all serve as positional devices to draw the eye to the main focus of the painting, the fishing boats.

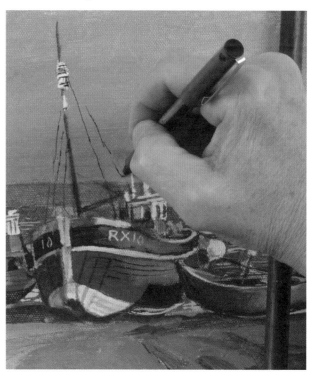

Use a lot of yellow ochre and burnt sienna to indicate the gravelly areas of beach. On the beach there are fishing nets and the cables securing the boats snaking toward the viewer. Use a larger brush, a no. 8, and almost pure yellow ochre with very little mixing white. Work across the beach, adding colour to the whole area, up to the boardwalk.

RIGHT Glaze using pure Payne's gray to indicate the shadows being cast by the boats.

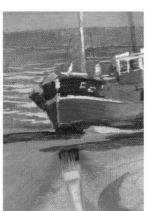

STEP 11 ▸▸

STEP 12 ▸▸

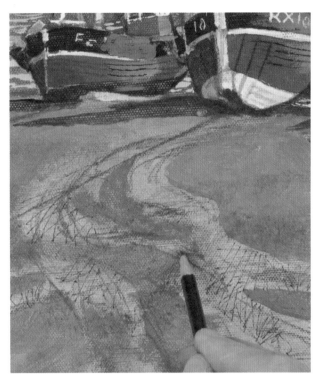

Drag some Payne's gray into the beach to get a bit of texture. You do not want any detail of pebbles since the boats are not detailed. Take some pure burnt sienna and bounce it into the beach area. Don't make the changes of tone too dramatic, otherwise you risk detracting from the boats. Lighten some areas of beach to give a few highlights. Mix white and yellow ochre, and work some highlights at the top of the beach. Rub gently backward and forward to define the area more carefully.

PAINT CONSISTENCY

Knowing when your paint is the right consistency for your intentions is a matter of practice and judgment. You want your colours to cover your surface, but in a composition like this one, you want colours to glide into one another, so do not make your mixes too thick and stiff.

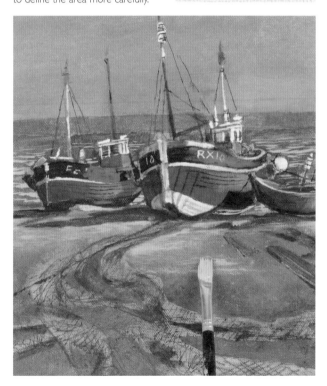

You can also use a pencil to indicate ropes and anchor chains. Take some Payne's gray and work it into the area of netting. This snakes down into the foreground.

RIGHT Next take some burnt sienna and flick it into the area of the chains. Then work a few little details into the area of flotsam.

STEP 13 ▶▶

STEP 14 ▶▶

If, when you have put in your highlights, the beach area is starting to look too golden, put some underlying beach colour back into it. Use fairly bold strokes. These brighter areas define the nets and bring the boats into sharper relief.

MIXED MEDIA

Using mixed media, such as the pen and ink here, adds a new texture to your painting. The quick-drying nature of acrylics makes them ideal for this: the paint is dry when you want to start pen and ink work.

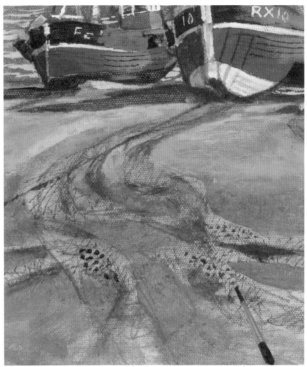

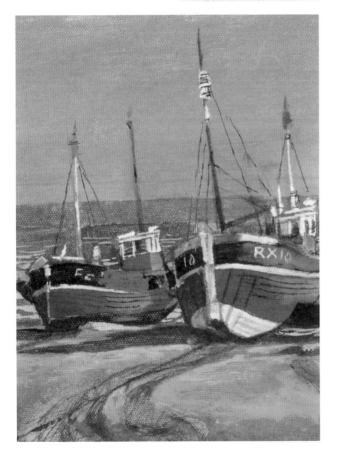

STEP 15 ▸▸

Use a fine brush to add a few more details into the nets. These marks give an indication of the texture of the nets.

RIGHT Finally define the edge of this area of netting but do not make this too stark, you do not want to draw the eye too much into the foreground.

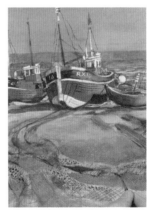

STEP 16

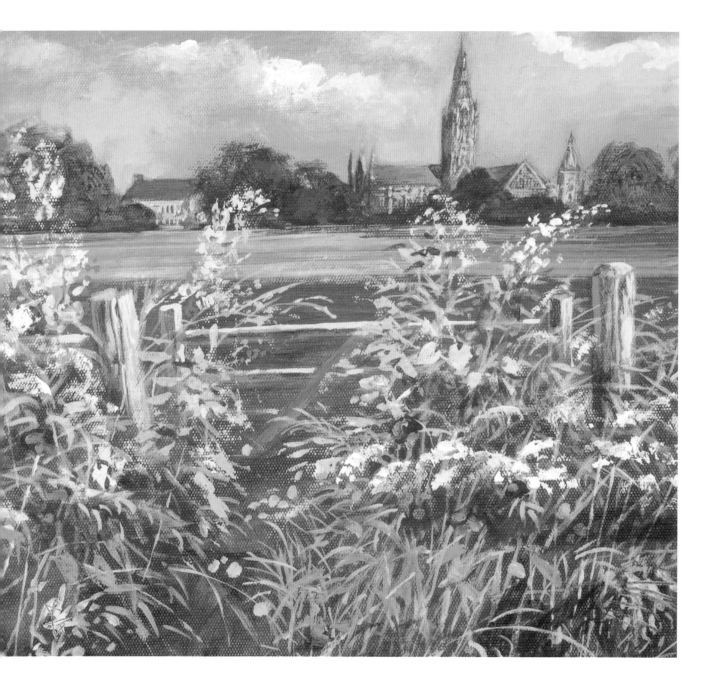

4
english meadow
john barber
270 x 350 mm (10½ x 13¾ in)

In this project with a very low eye level, the foreground plants take up most of the picture area and so become the main subject. In order that the eye remains focused on them, the buildings on the skyline must be kept simple, with only slight indications of architectural detail and the trees rendered as simple silhouettes. This project explains how the various brush techniques can hint at the complex rhythms of the meadow plants. When looking for subject matter in the countryside, sitting down on a stool or on the ground will often show dramatic changes in scale and centre of interest. Use your sketchbook to record the same scene from several angles and heights to suggest to you many different approaches to a subject.

TECHNIQUES FOR THE PROJECT

Fine lining with sables

Painting with a palette knife

WHAT YOU WILL NEED

Tinted canvas
Graphite pencil, 3B
Straight edge
Black chalk
Brushes: flat hoghairs nos 2, 3, 4, 7, and 9; round sables nos 2, 3, and 4
Palette knives

COLOUR MIXES

1 Payne's gray
2 Viridian
3 Burnt sienna
4 Yellow ochre
5 Cadmium lemon
6 Cadmium yellow
8 Cadmium red
9 Permanent rose
11 Cobalt blue
12 Ultramarine

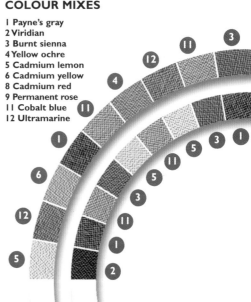

PAINTING WITH A KNIFE

Palette knife painting is more suited to acrylic paint than to any other medium. Because acrylics can be built up to great thickness without any technical problems, and they dry so quickly, many layers of paint can be applied to the picture surface in a single day. The term palette knife painting is perhaps a bit of a misnomer these days, some of the delicate blades that have been devised so that intricate work can be done entirely without the use of brushes are more like surgical instruments. Indeed scalpels and all kinds of plastic spatulas can be used to apply paint to canvas or board. In short anything that will deposit paint exactly where you want it is the right thing for you to use. As with brushes, limiting yourself to one knife will limit you technically, but those very limitations will impose a style and teach you to be ingenious in your handling of the paint. Choose a large and a small knife to start with and then build up your range as you become more confident. The viscosity of the paint, so important in all painting, is especially so when spreading paint with a knife. A finished effect like coloured butter has a unique aesthetic appeal. For this reason, you may find that you need to modify your acrylics with water, flow enhancer, or gel medium.

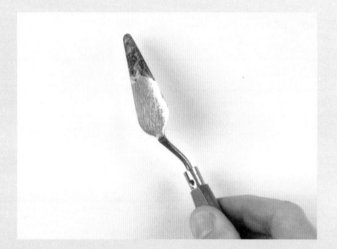

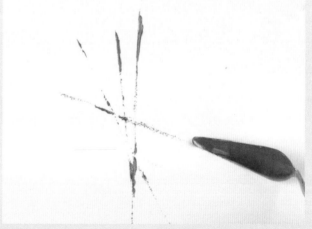

1 Mix up plenty of paint before you start palette knife painting. Take a small trowel-shaped palette knife and scrape some paint off the palette so that it is on the underside of the knife. Make sure that the paint is along the edge of the blade.

2 Apply the edge of the knife to the canvas and pull it toward you. If you wish to strengthen the line it makes, twist the blade so that more of the surface is in contact and a thicker line will appear. Practice making thick and thin lines.

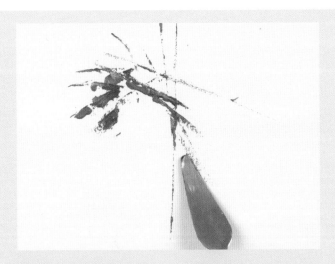

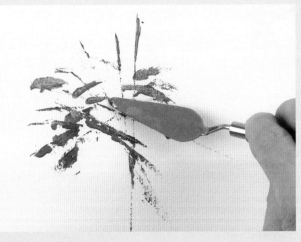

3 As you begin to use the flat of the blade, broader, wedge shapes will appear from under the knife. With knife painting, you will not see what mark you have made until you move the blade. Hold the knife at the same angle to make an identical mark.

4 Continue to put the knife down at different angles, checking the results and getting the feel of the paint under the blade. Alter the texture of the paint by adding some water to the colour on the palette if the paint is not moving easily.

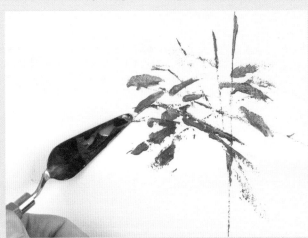

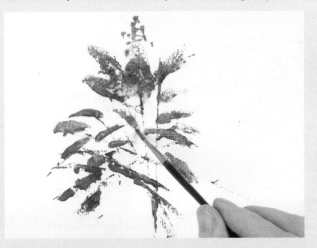

5 As your marks begin to form some sort of pattern, look to see what you can develop from them. If an image suggests itself, try to draw it with more knife strokes. This sketch might be a plant so try some longer strokes like bamboo leaves.

6 Obviously there is a limit to the detail that can be rendered with a knife and, except in expert hands, it is a technique with an element of chance in the finished result. Here add a few finer touches with a small sable to indicate stems.

4
english meadow

Having established a dark tone on the canvas, coat the sky with white paint, then rub some ultramarine into it to give you a clear sky. Draw on the dry sky using a soft graphite pencil. Get a detailed profile of what you can see in the distance. Check to make sure you are getting a true vertical for the centre of the spire, using a straight edge. If the building looks to be tipping over later, it will distract you from the rest of the work.

EYE LEVEL

This composition of a typical English landscape is going to have a low eye level. Although there are buildings in the distance, the real subject will be the foliage and plants in the meadow in the foreground. Establishing the horizon and the buildings is important. for the success of the composition, even though they are not the main subject.

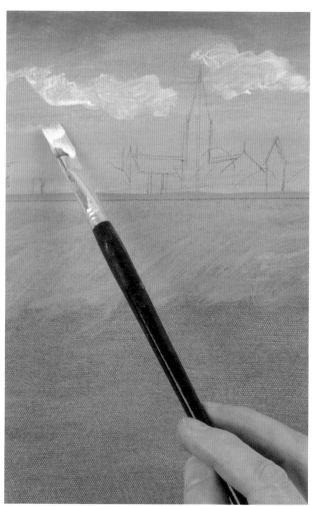

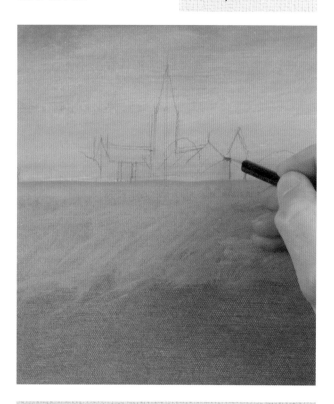

STEP 1 ▶▶

Mix up a slightly creamy white for the clouds using titanium white, mixing white, burnt sienna, and yellow ochre. Take nos 7 and 9 brushes and start to paint on the sky. Use the white paint fairly thin so that the sky shows through. Work the paint across the canvas to gradually build up banks of high cloud.

STEP 2 ▶▶

Now move down to a no. 4 flat brush and put the building in, using a warm grey mixed from burnt sienna and ultramarine, with a touch of yellow ochre and some titanium white added. The whole building can be worked as a silhouette, using the small brush to keep the outline clean. You do not need a lot of white in the mix at this point, just enough to cover the blue sky and establish the building's contours. Then put some tone on the adjacent roof.

ARCHITECTURE

In a painting like this one, you need to make simple marks on the building to suggest architectural detail. At this distance, you are simply catching the tops of the grain of canvas. This breaks up the paint, and can give a more convincing note than slavishly working details onto the buildings.

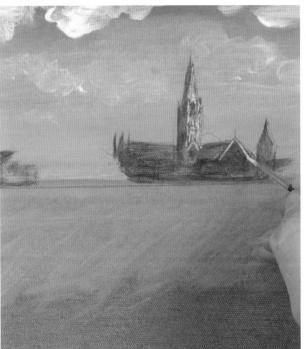

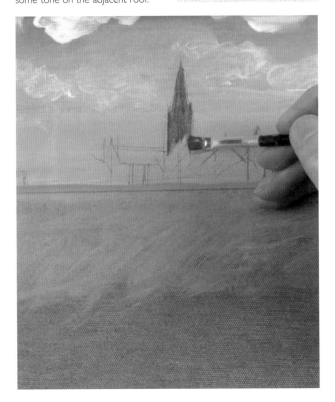

Take a pointed no. 2 sable to work the detail on the spire. Use the previous wash colour, mixed with more white for a creamier colour. Put a few details onto the church. Dragging the brush down gives a good hint at architectural detail. This might need more detail later on, but at this stage, you are establishing where the light is falling. The end of the building is in darkness but light is shining on the edge of the roof.

RIGHT Then add the side of the house.

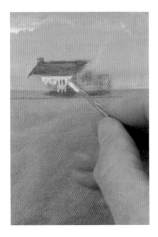

STEP 3 ▶▶

STEP 4 ▶▶

english meadow

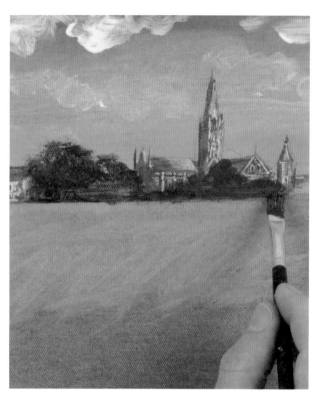

RIGHT Add more blue and white to the mix to create a stronger colour, and scrub this into the canvas. This colour will mostly be overpainted, but small areas will remain to form the gaps between the foreground foliage.

Put more cobalt to the mix as you work into the foreground. This colour should not be too light. This colour has some texture; it does not need to be flat. Only small areas of this will be visible when the foreground is painted in. Add some burnt sienna to the cobalt blue for the very bottom of the canvas, to get tone into this area.

Move now to putting in the trees. Mix ultramarine and cadmium lemon, keeping plenty of blue in the mix as the trees are fairly dark. Establish the horizon at the edge of the meadow, and work up into the sky. Drag the paint to break up the outlines of the trees.

RIGHT Mix yellow ochre, cadmium yellow, and cobalt blue for the distant greens, and work across the canvas, adding in the edge of the meadow.

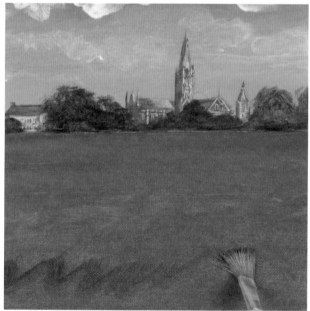

STEP 5 ▸▸

STEP 6 ▸▸

Next, work in the horizontals of the gate and finally add the diagonals. This completes the gate for the time being.

MAKING CHOICES

A picture feels balanced to the eye if one area only attracts attention. A strong landscape, a dramatic sky and a detailed foreground will compete for attention. Choose one focus in your picture. If the foreground is your focus, suppress the background and keep the sky simple.

To lighten the meadow in the distance add a strip of white, cadmium lemon, and a touch of cobalt right across the painting.

RIGHT Indicate where the fence is going to be, using chalk. Take a no. 3 hog brush and mix Payne's gray, burnt sienna, and white, with a touch of yellow ochre to give a pale colour. The Payne's gray adds coolness, to enhance the impression of old, weathered wood. Draw gateposts, then the verticals of the gate.

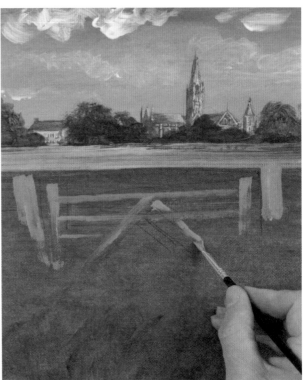

STEP 7 ▸▸

STEP 8 ▸▸

4 english meadow

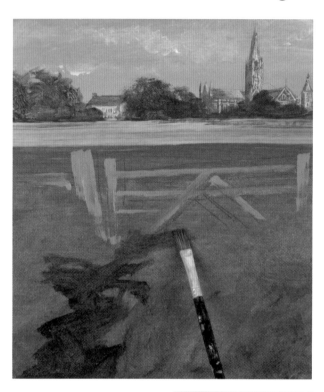

RIGHT Now start to make stronger marks. Use the grain of the canvas to break up the flower heads so that they don't look too contrived. Use the tips of the bristles to create blobs of colour: you could spread these out using the end of the brush handle.

Switch to a no. 2 sable and work in greater detail. With the sable brush and more liquid paint, you can move the paint further.

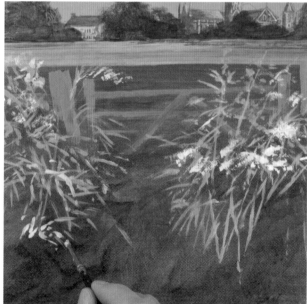

Start adding darks in the foreground. Scrub in a mix of burnt sienna and ultramarine. If the foreground needs to be darker still, work over it again.

RIGHT Turn now to the foreground foliage. This is going to be quite complicated. You will need small hog brushes, nos 2, 3, and 4. With titanium white start to indicate foliage. Make sharp, clean, small marks.

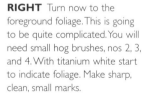

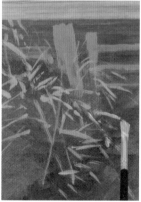

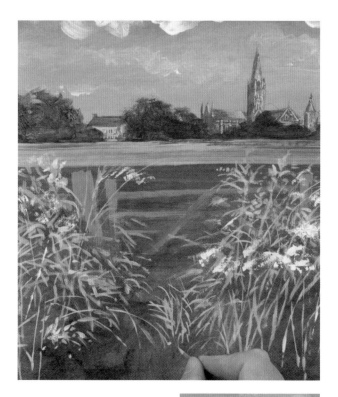

RIGHT Rub white paint onto the canvas, keeping your marks loose. Lighten the sky still further.

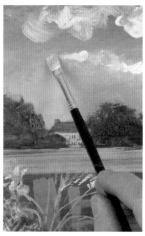

Next paint up a bit of the gate. A mix of Payne's gray and burnt sienna should give a good weathered look. Add a little ultramarine too.

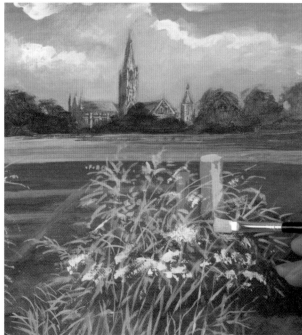

Go back to the bluer foliage colour and work this in with the sable, to give another tone for the leaves. Work around the foreground, adding in this colour, to indicate different grasses.

RIGHT To lighten the sky, rub some white and cobalt blue into it. Work around the buildings.

STEP II ▶▶

STEP I2 ▶▶

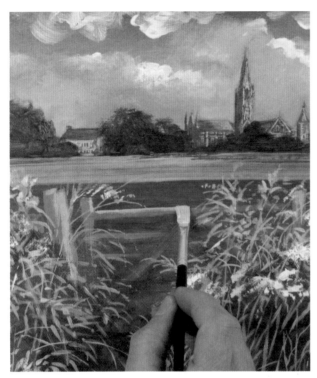

Marks made with a palette knife appear almost accidental. Now take some bright yellow and work this in.

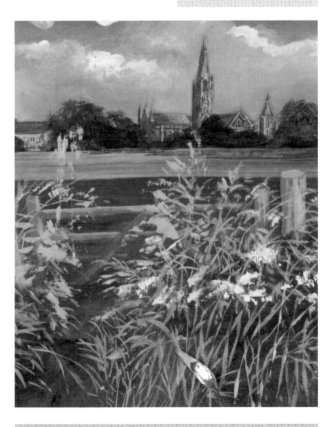

The light is coming from the right, so work highlights accordingly. Work along the horizontals of the gate, placing the lighter tones. Add highlights to the uprights, then get back to painting in the plants in the foreground.

RIGHT Mix up some titanium white, cadmium yellow and cobalt blue to create a yellow tone for some of the plants, and start to apply this using a palette knife.

STEP 13 ▶▶

STEP 14 ▶▶

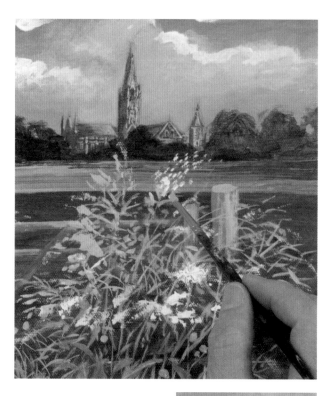

Now take some pure permanent rose and use this here and there to give an indication of poppy heads. Then add some white to the colour to make it more solid and dot this around, but don't overdo this. Add a touch of white to some cadmium yellow and use that to suggest some yellow flowers dotted in the meadow.

KNIFE AND BRUSH

Even when you put paint on with a palette knife, you can still work into it with a brush, moving it around and changing the shape of the marks. When paint is put on with a knife, it is likely to stay wetter for longer, so you can continue to work it.

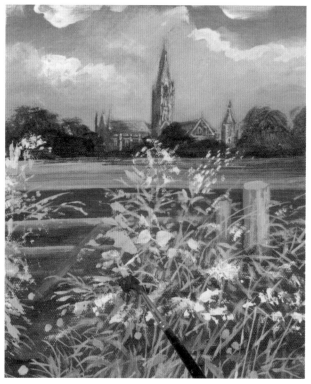

For the seedheads, mix up some viridian with a touch of burnt sienna to tone it down and apply using a hoghair brush, here and there. Avoid the temptation to get too detailed. You can overdraw as the painting progresses if you find it needs to be more detailed.

RIGHT Add some whites, dragging the paint on with the palette knife.

STEP 15 ▶▶

STEP 16 ▶▶

4 english meadow

RIGHT Add white to the cow parsley heads to model them more. Then start to break up the areas that are looking too solid using a mix of ultramarine and burnt sienna and work some darks here and there to indicate gaps between the grasses and flowers.

Now mix burnt sienna and Payne's gray to work some darks into the gate. Then add more titanium white to your grey mix and start to re-define some of the lights on the gate.

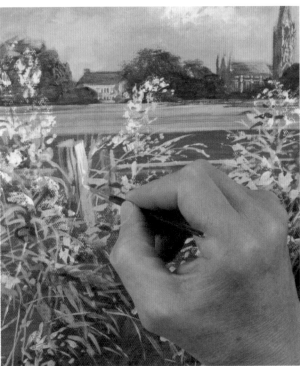

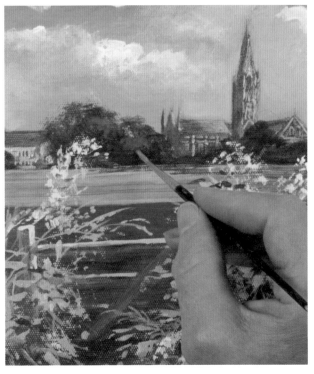

Take some cadmium lemon with a touch of cobalt blue added and drag some green into the trees in the background. Be careful with this, as you do not want to bring these trees too far forward: they must stay in the background. There are areas of texture in the trees that you can leave to contribute to the modelling. Then mix some burnt sienna and white and use this to flick some red flowers into the foreground.

STAFFAGE

To add interest to your picture, try putting in figures and animals. Use tracing paper over the picture and sketch in the figures to scale. You then have the chance to slide them around to the best position before tracing them down. With acrylics you can always paint them out again if you don't like the way they look.

Use this same colour mix on the roof on the building on the left. Now take a creamy colour and start to work a little more sunlight into the buildings. The roofs now need to be bluer. Mix a little ultramarine and Payne's gray and use this to make the lead on the roofs lighter and more blue. Then mix a glaze of viridian, cadmium yellow and a touch of burnt sienna to take over parts of the foreground to give the effect of a change in light.

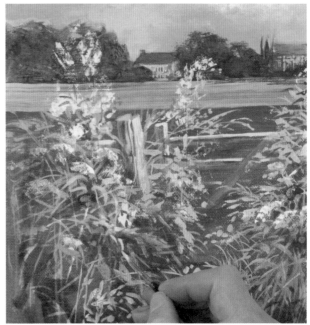

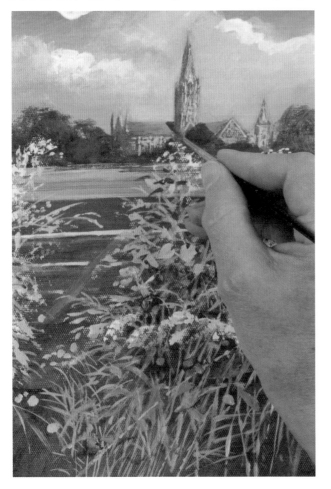

STEP 19 ▶▶

Go back to your cadmium lemon and white mix, with a touch of viridian, and add one or two more lights. Work lights coming out of the darks you have just added. This gives the foliage a more natural appearance. Bring some colour into the foreground.

RIGHT Work some lights in the foreground where the grasses are catching the light. Stand back and review your painting. At this stage, it was apparent that the viridian shadows were too strong a green, so these were overglazed with a touch of burnt sienna, to dull them down.

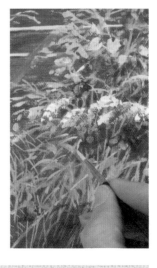

STEP 20

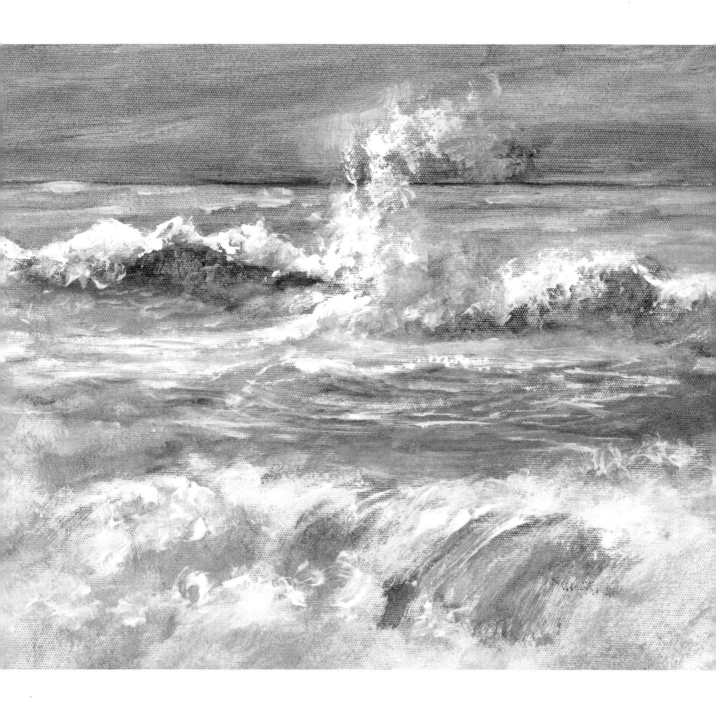

5
breaking wave
john barber
220 x 310mm (8½ x 12¼ in)

Painting the sea allows you to experiment with brushwork and colour in a very free manner. Since form is not so obvious and movement and light are never still, rapid and free paintmarks are best to capture some impression of the movement of water in any medium. With acrylics, you can pile on more paint or tone down your contrast until they seem right. This project demonstrates the importance of velocity in painting, that is, the speed that the brush is moving at when it leaves the paintmark on the canvas. Learning something about this aspect of painting by practising free movements of your hand and brush is far more important for your development as a painter than strict copying of this painting.

TECHNIQUES FOR THE PROJECT

Very free brushwork

Palette knife painting

Scrubbing in colour

WHAT YOU WILL NEED

Coarse-textured canvas board
Black crayon
Straight edge
Brushes: flat hoghairs nos 5, 7, 9, 10, and 11; flat sables nos 3 and 4

COLOUR MIXES

1 Payne's gray
2 Viridian
3 Burnt sienna
4 Yellow ochre
11 Cobalt blue
12 Ultramarine

TRANSPARENT AND OPAQUE

The influence of the painting surface on the finished picture often passes unnoticed. What you choose for your support, or painting surface, is vital to the finished result. From the moment you take up a canvas or board and begin to consider the underpainting you should be gauging its influence on the picture you have in mind. A tinted ground in a neutral colour is usually necessary for a picture which relies for its impact on the use of solid painting with a knife. By using an opaque colour, without a mixture of white, for instance very dark green, as here, and vigorously scrubbing it onto the tinted ground, an impression of the turbulence and flow of water can be suggested. You can alter this as much as you like while the paint is still wet. Add water to your paint, to allow some parts to be transparent and let the ground influence your finished colour. When you are satisfied with the look of your waves, let them dry, then use these impressions to influence where you place your solid palette knife marks. Part of the powerful effect of applying paint with a knife is that the paint is laid on so thick that the weave of the canvas no longer moderates the surface so that paint appears brighter and, as it is raised up, it has edges that catch the light from all angles. Flat acrylic paint would not give the same effect.

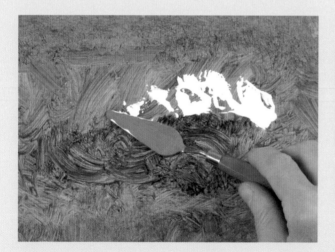

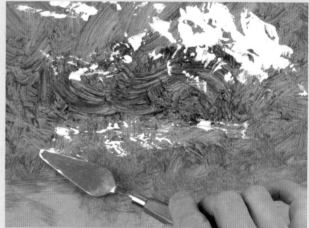

1 Scrub some dark green onto a tinted canvas with a stiff brush. This will leave lots of textures of crisp lines and some blurred areas. Mix some water with the paint to get this effect. When it is dry, add white with one stroke of your knife.

2 A lot of the excitement with this sort of painting is the uncertainty about what the paint will do. Some accidentals that look wrong at first will turn out to be exactly right if you change your mind about a subject. Move your knife and see what happens.

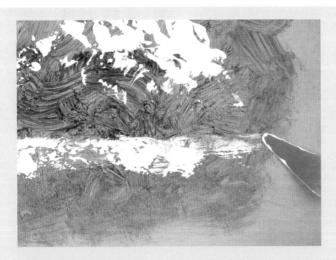

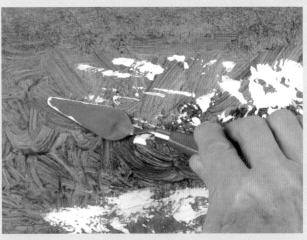

3 Your exercise will not look like this demonstration, so relax and enjoy what happens on your practice sheet. In step 2 the knife going from right to left hardly shed any paint; in this one going back with a little more pressure left a dramatic stripe.

4 Without reloading the knife, let it bounce about. Hold it very loosely so that each time the blade touches the canvas it makes its own shape, becoming weaker and less complete as the paint is left behind. This leaves a rhythm of diminishing marks.

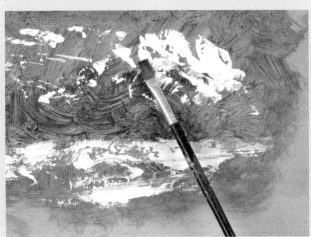

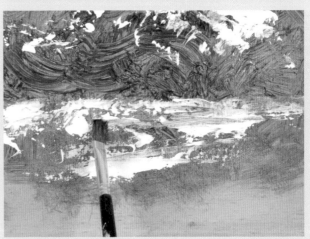

5 Take a small, dry flat hoghair brush and wipe it into the still-wet paint, and drag some of it onto the background. In this way you can begin to manipulate the accidental marks closer to your intentions. Here is a suggestion of a wave.

6 Finally, wet your brush in water and stroke it about on the light areas so that the palette knife marks begin to blur and soften. This gives you the option to continue your study with brush painting. Confidence with the knife will come gradually.

5
breaking wave

Start by deciding where your horizon is going to be and rule it in using a straight edge and a black crayon. With a subject like this, the exact position of all the elements is not as important as it would be in an architectural drawing. Draw in your main shapes. The relationship between these shapes is going to be important. Indicate the rocks in the foreground. Lay out your palette: the main colours will be Payne's gray, ultramarine, cobalt blue, viridian and burnt sienna.

WET CANVAS

Don't be afraid to use water directly onto your canvas to get the texture you want. However, be careful not to obscure any drawing marks you need. Some of your initial brushmarks may be left in the finished painting if they contribute to the overall shapes you are looking to create, such as the waves in this project.

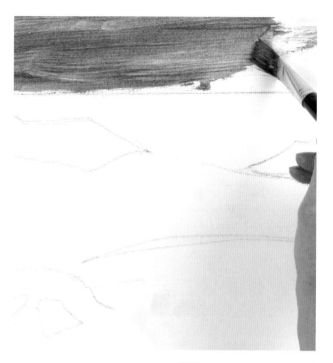

Use a medium-sized palette knife to mix Payne's gray and cobalt blue, dip your brush in water and mix to the consistency of a watercolour wash. Apply that to the sky area using a no. 11 brush. Work the brush parallel to the horizon. If you keep your brush going with the thin wash you may have enough paint for the sky. Use the stiffness of the brush to spread the paint.

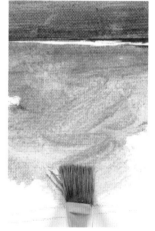

RIGHT Mix up a very thin wash of cobalt blue, brushing from your horizon line downward.

STEP 1 ▶▶

STEP 2 ▶▶

WATERY MARKS

With a subject like this one, in particular, be aware of the accidental nature of the marks you are making. Look for those marks that look as if they might be moving water, and leave them. Look at the rhythm of your brushstrokes: if you see one that looks wavelike, keep it for later and work it up into the finished painting.

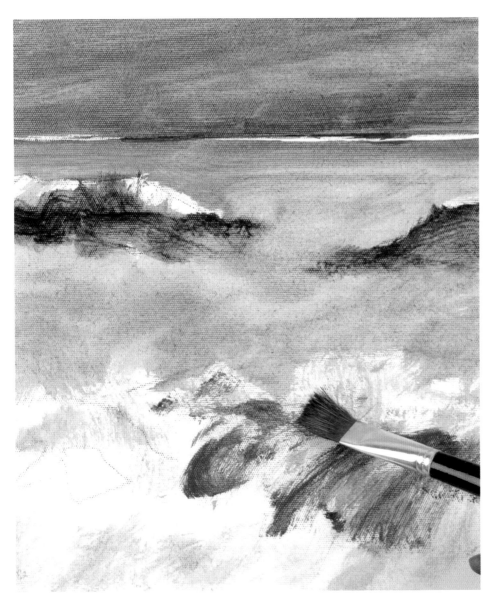

Add some Payne's gray to viridian on the palette. Then add some burnt sienna to the mix and use this to establish the dark areas. To this dark mix, add some more cobalt blue to establish the darks at the lower edge of the picture. Gradually make some dark marks into your colour wash: this is still wet so the colours will run one into another.

5
breaking wave

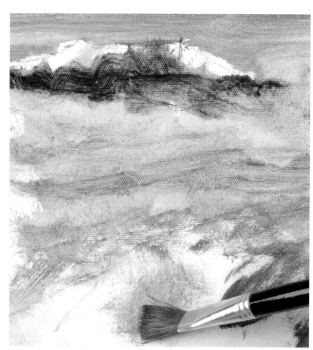

Introduce some warmer colours to indicate that the waves are dragging up colour from the beach. Mix a thin wash of yellow ochre and burnt sienna and apply it using a no. 10 brush. Indicate where sunlight is falling under the shadow of a wave. If the underlying colour is still a little wet you will get some blending. Gently apply a little cobalt blue and viridian to your remaining areas of white canvas so that the whites are not quite so stark. Mix a very thin wash, so that it is almost tinted water.

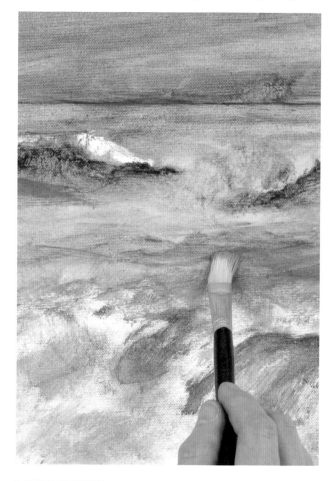

Now introduce some shadows into your plume of spray. At this stage every mark has some energy. Scrub an almost dry brush across to give yourself some tone. Gradually get some paint into every area of canvas.

RIGHT Blend a little colour before the paint dries. The white line between sea and sky has now been obscured. In pulling the brush across the canvas, the sea has become slightly lighter than the sky: that is the effect you are looking for as it establishes the tones of the composition.

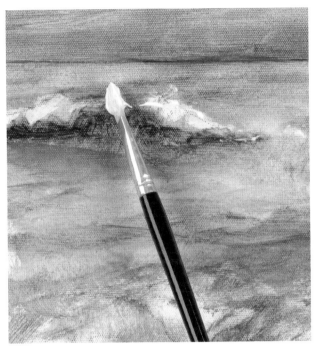

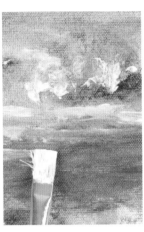

RIGHT Wet the sea area. Take a no. 9 brush, and white with a touch of viridian and cobalt, and roll your brush across the caps of the waves. Keep the surface wet enough to allow you to move your brush across the canvas.

Hold the brush loosely up toward the end of the handle and let the weight of the brush on the canvas do some of the work. Don't try to copy too carefully, but where there are lighter areas of soft tone, get the maximum effect of your white.

The accidental white patches are important in your composition but they need toning down. If you tone them down when the paint is almost dry, they remain but lose their harshness. When you start to add white, you will be able to pick these out. Cover any remaining areas of unpainted canvas.

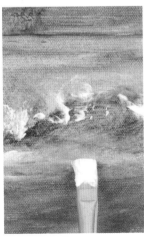

RIGHT To establish some bright areas use pure white with a touch of viridian so that it is not too chalky looking.

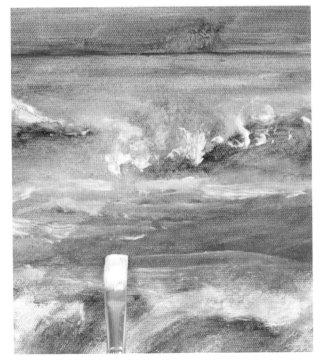

STEP 6 ▶▶

STEP 7 ▶▶

5
breaking wave

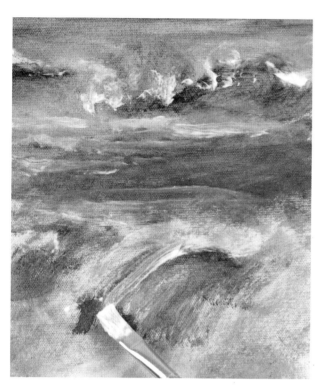

RIGHT Start to look in more detail. Look at the accidental marks to see how they can be manipulated to give the effect you are looking for. Use the flat edge of the brush to indicate the caps of the waves rolling in from the horizon.

Don't feel you have to use the whole edge of the brush, use the corner to get detailed marks. This gives you better marks than a small brush. The marks here are still random and spontaneous.

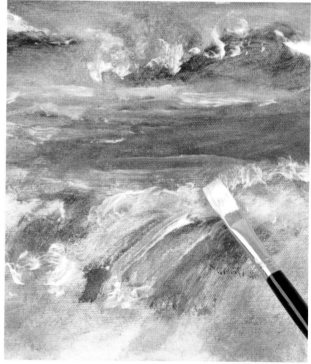

Take these marks up under the shadow of the wave. Don't worry if these areas get too light, they can be glazed back down again later. Work some light into the shadows: a blue glaze will be added later. Continue across the painting, creating foam highlights. Allow the paint to dry, then start to apply some more solid white. Use pure white and the no. 9 brush to get some solid whites into the painting.

TRICK OF THE TRADE

Timing is important with acrylics: when you start to overpaint using a wash, it may drag up too much underlying colour. If this happens, leave an area and come back to it once it is completely dry. Remember that you can always wet an area again, if you want to create a more watery appearance in places.

STEP 8 ▶▶

STEP 9 ▶▶

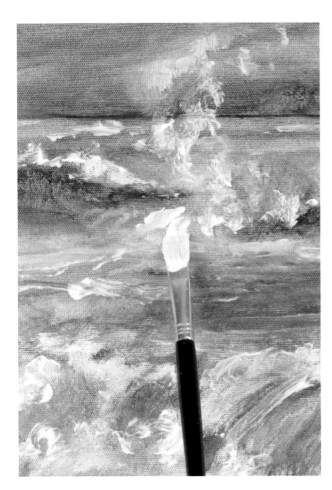

RIGHT Now is the time to put your larger brushes aside and do some more detailed drawing work, to get the patterns of the waves. Flick paint into the waves in the foreground.

Start drawing the patterns of the lines of foam. Put your brush into water to wash the colour out. Take a small sable brush, no. 2 or 3. Begin to make discrete little marks, bouncing about to get an idea of foam.

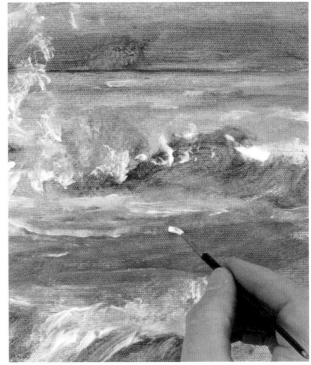

Add some white into the sky and blend that. Then, start work on modelling the plumes of spray going up. Wet this area of the canvas again. It's important that the colour is dry before you start to add your white lights. However, to make white 'melt' into the canvas, wet the canvas again. This will give a more subtle effect than simply applying paint to the dry canvas, but means that you do not pick up underlying colour and modify your white in areas where you want to keep it clean and bright.

STEP 10 ▸▸

STEP 11 ▸▸

5
breaking wave

Use pure white and a larger, no. 9, brush to get some solid whites into the painting. Let your brush do the work, rolling it around to create movement in the shapes of the waves.

RIGHT By dragging pure white onto your canvas with an almost dry brush, you will find that the texture of the canvas influences your painting. Continue to drag white across the canvas.

BE BOLD

This subject is ideal for losing inhibitions. The very nature of the sea invites risk-taking by the painter. The more accidental your brushmarks appear, the more natural will be the effect. Let your brush plough through thick paint or slide through wet washes to suggest facets of the waves.

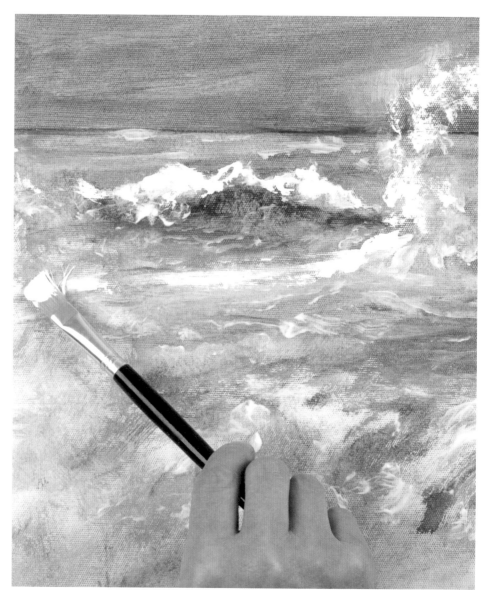

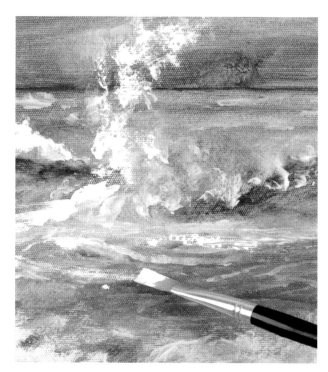

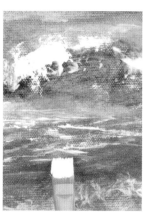

RIGHT Create the caps of the waves, with the hairs of the brush flat on the canvas.

Semi-dry paint breaks up to give a foamy effect to the water. Use the flat of the brush to blend the colour a little. Now go back over the centre of the canvas, where there is too much white. Paint a few darks into the waves using a mix of viridian and ultramarine: this is slightly cooler than cobalt to give a more purply effect.

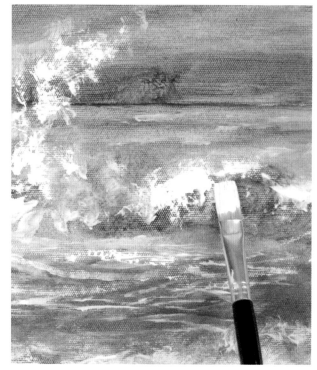

The edge of your brush will allow you to make fine lines. This can be as effective as using a small brush in certain circumstances, as on the crests of these waves.

EASE OF USE

With acrylic paints, you have the opportunity to control the types of marks you make. If you want your paint to run more freely and create marks with movement and spontaneity, dip your brush in water. For more controlled marks keep it drier. Your marks can always be blended together simply by dragging your brush across them.

STEP 13 ▸▸

STEP 14 ▸▸

5
breaking wave

RIGHT Make sure that your solid whites are dry before you start to glaze them with colour. Take some ultramarine and water to make a wash consistency and use this to tone down areas that are looking too bright.

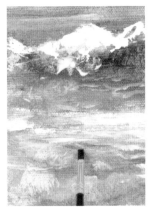

Use the same glaze to tone down the detail that is in the shadow of the rocks.

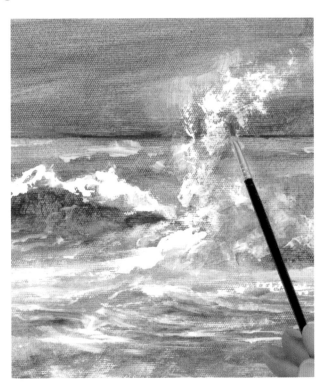

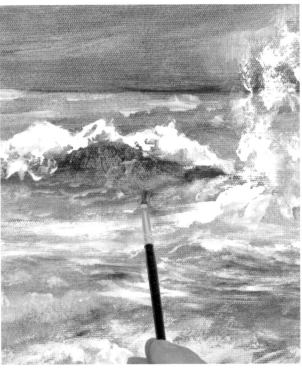

Bring the glaze over the pure whites of the waves to soften them down. Continue around your whites, gradually toning them down using a fine wash of ultramarine.

PAINTING OUT

If you find at the end of a project that you are unhappy with the result, mix up some ultramarine into a fairly strong wash and glaze it over the whole picture. This will bring all of the colours closer and tone down any harsh contrasts. While this is still wet, wipe clear some of your highlights, then let it dry.

STEP 15 ▸▸

STEP 16 ▸▸

The ultramarine glaze changes the colour of your whites completely. Work over the crests of the waves. There are areas that need glazing in the top right of the painting and in the foreground. Then start to work the ultramarine glaze into the greener areas of the painting, running it around the rocks on the left and then work the same colour into the shadow on the right to make that more distinct. Establish a little more definition into the greener areas of the sea itself. Then, using the pure titanium white and a no. 4 brush, drag some pure white into the canvas to give the central wave a highlight.

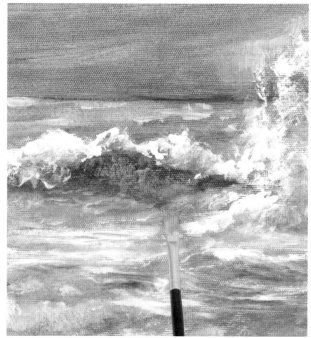

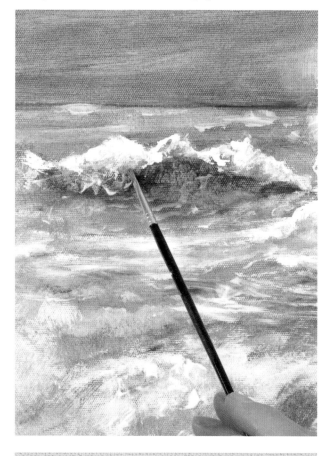

STEP 17 ▶▶

Mix some yellow ochre with a little white and not too much water and use this to differentiate the flat water from the shadow under the wave. It's important to make sure this is a smooth line, to indicate that this is an area of cast shadow.

RIGHT Finally look around the canvas, and add touches of glaze where you need them.

STEP 18

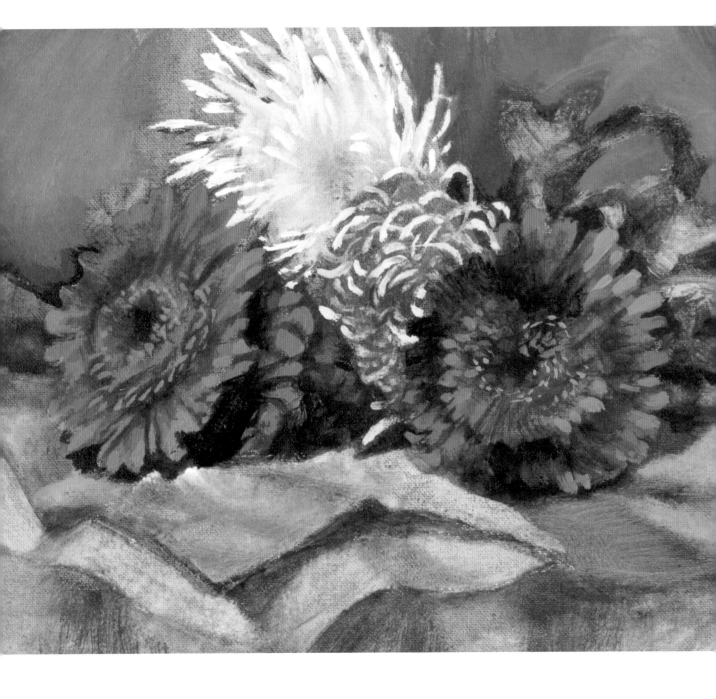

6

bunch of flowers

john barber
225 x 310mm (9 x 12 ¼ in)

Flowers have been favourite subjects for artists since painting began. In this project the subject was not arranged, but an attempt was made to render the flowers just as they fell on the table with their wrapping paper under them. The main interest is the contrast between the strong disk-like form of the red flowers and the spiraling white petals in the centre. The concentric circles of petals, which get larger as they spread, are painted as blocks of colour, particularly where they catch the light around the edges. Their lighter tone, although not closely detailed, provides more information about their structure. By contrast, the lighter flowers flow freely around, and define the shape of the orange flowers with points of light.

TECHNIQUES FOR THE PROJECT

Painting from dark to light

Glazing

Building solid highlights

WHAT YOU WILL NEED

Canvas board
Brushes: flat hoghairs nos 2, 3, 4, 6, and 9; round sable no. 3
Kitchen paper

COLOUR MIXES

1 Payne's gray
4 Yellow ochre
5 Cadmium lemon
6 Cadmium yellow
7 Orange
8 Cadmium red
10 Violet
12 Ultramarine

PRECISE KNIFE PAINTING

The basic techniques of acrylic painting are simplified by the fact that the only substance needed to dilute your paint is water. Acrylics lend themselves to use in the early stages of a painting, when thin transparent washes, made from the paint as it comes from the tube, watered down as required, is all you need to get your canvas covered. If the paint is not thoroughly mixed, but allowed to be carried in the water, many textures of stripes and bubbles will be left when the water has dried. The exploitation of these qualities can give immediate results that are so attractive you may not want to elaborate any further. A

disadvantage is that it is difficult to lay a flat wash in transparent acrylic and, if you need an absolutely flat finish, the addition of some white is going to prove essential. Many areas in the bunch of flowers study have this first wash quality and, in a more finished picture, would be built up in solid layers of opaque paint to give more subtle modelling and colour matching. However thick the paint on your more finished paintings, you still have the option of applying transparent glazes which are the same as your first washes at any time without running the risk of any technical problems.

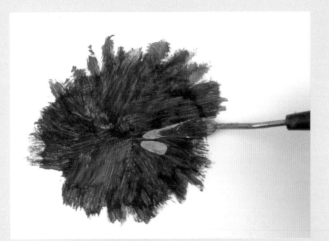

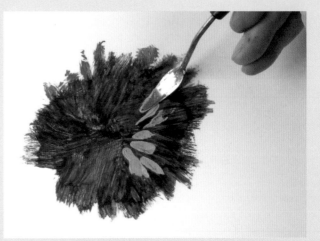

1 In this project, you will be working through the first stages of painting a blossom. Mix up your flower colour without adding white and, with a small hog brush, drag each brushstroke out from the centre so that any brushmarks will radiate outward.

2 Adding some white to your colour mix will give you a tonal contrast for the next stage which is suggesting the light on each petal. Do not tidy up the darker colour but concentrate on making petal shapes with the palette knife.

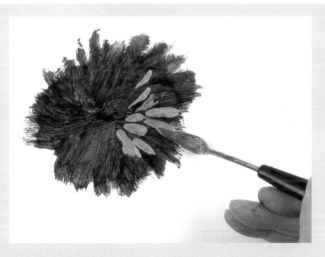

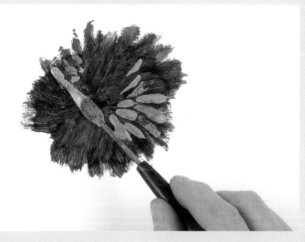

3 Now start making marks using your smallest palette knife. Gradually move around the flower. keeping the lighter patches separate at this stage. You will be adding some modelling onto the leaves later in the study.

4 Make distinct marks by touching the canvas firmly and then lifting the knife. Gradually add to the circle of marks. Turn the canvas around so that without moving your hand you can make the same shaped marks all around the flower.

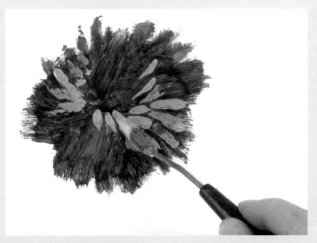

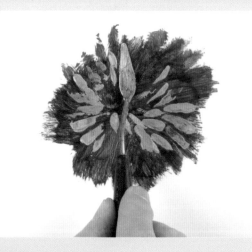

5 You have now reached the stage where your marks can be allowed to overlap or touch each other. Try to complete concentric circles as part of the practice. When they are dry, glaze background colour over some of the lower petals.

6 This exercise has been designed to give you experience in controlling the palette knife before you tackle the project on the bunch of flowers when you will have the choice of using either brush or palette knife.

6
bunch of flowers

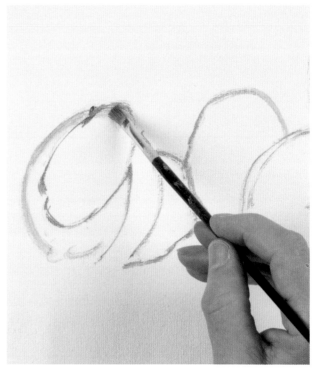

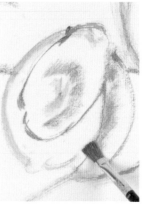

Sketch in the shapes of the flowers using a thin wash of ultramarine and a no. 4 flat hog to establish the main shapes on the canvas. This wash will dry very quickly. Indicate where the centres of the two orange flowers will appear.

ALLA PRIMA

For this painting, the colour sketch is alla prima, literally at once. The colour is painted wet, rather than built up in layers. However, by accenting the drawing with one or two main shadows, you are very early on establishing areas of light and shade.

It is important to establish the elliptical shapes of the flowers and the points from which the petals radiate.

RIGHT Use some of the blue to give an indication of tone, by applying it with a dry brush on its side. Indicate where the light is coming from, with an arrow. If you can see any areas of deep shadow, indicate them in blue.

STEP 1 ▸▸

STEP 2 ▸▸

MAKING MARKS

The marks you make will be dictated by the stiffness of the paint, the texture of the painting surface, the flexibility of the brush, and the speed of your hand. When you get all these under control, you will have found your 'touch'. This will affect the way you interpret your subject and will define your personal way of painting.

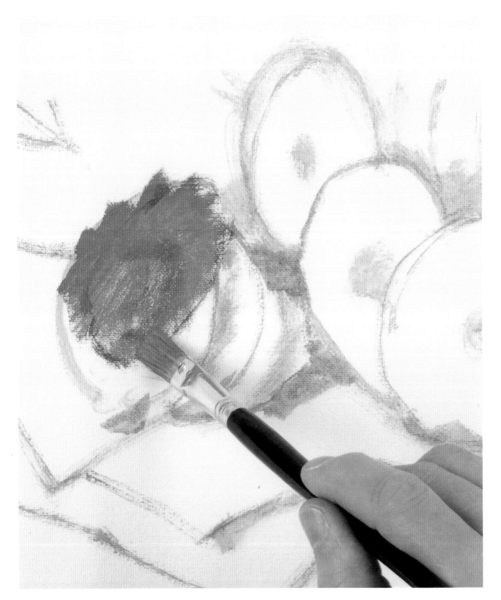

Now switch to a no. 9 brush and mix up the most powerful colour in the composition, a deep orange. Check how that matches the flowers in front of you. Bearing in mind the direction of the petals, start to paint. The brushstrokes follow the direction of the petals, radiating out from the centre. Trust your own judgment: if a radiating mark looks right, keep it in the composition and add to it. Where your orange paint covers the blue underdrawing, you are already creating your shadow colour.

STEP 3 ▶▶

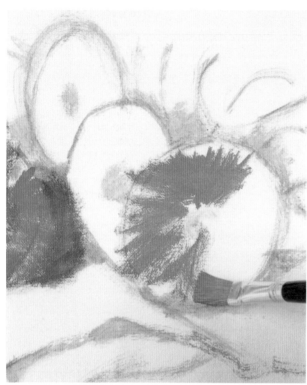

RIGHT Start to put the background colour in as a thin wash, to help you to judge the strength of the flower colour. This is a mix of violet and orange. Note how much brighter the orange looks once the violet paper is added.

The paper still has some folds and texture in it. The texture can be left or overpainted later. Use the violet to cut out the shapes of the leaves.

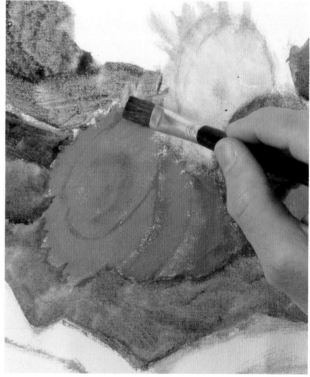

There are some areas of white canvas glinting through still. Don't worry too much about detail at this stage, but do look at the shape of the flowers and note that they are not perfect ellipses. The petals fall in a random way.

RIGHT Work some darks into the green curly blossom. This is a mix of ultramarine and cadmium lemon and will be used for the green foliage.

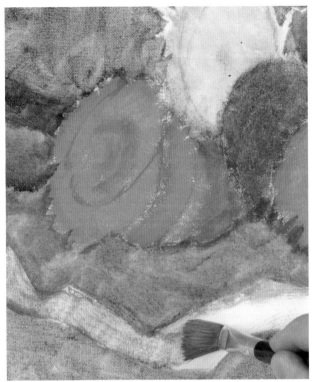

Note at this stage that there is a subtle double row of petals on the orange flowers, and that there are shadows on the left of the flowers and cast shadows on the right. Now, go back to the no. 4 brush and put a glow of cadmium lemon into the centre of the white flower.

LIGHT AND SHADE

Don't be frightened to make full use of shadows in your compositions. In the early stages it is easy to be concerned that you are darkening all your 'brights' too much, but here the brightness of the flowers will be recovered once you start to add white to your paint mixes. At the beginning of a composition, simply establish the pattern of light and shade.

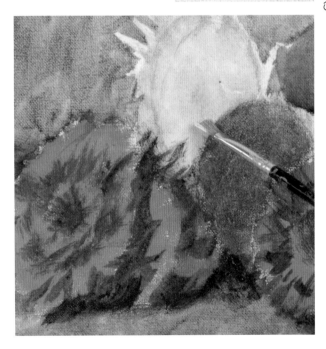

Tone down the other piece of wrapping paper so that it is not too stark. Use a thin wash of background colour with yellow ochre added. Apart from the leaves, all canvas now has some colour on it.

RIGHT Make the darks stronger by adding a little violet to the orange. Use the no. 9 brush to keep a broad feeling to your brushstrokes. Build in some darks, using a stiffer mix of paint.

STEP 6 ▶▶

STEP 7 ▶▶

6
bunch of flowers

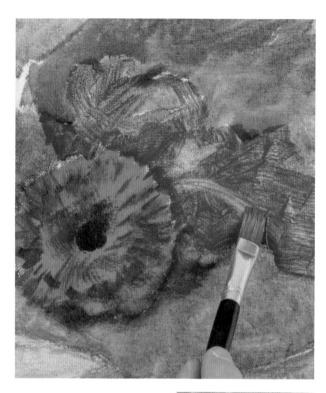

RIGHT Start looking at the edges of the petals against the background. Each brushstroke makes a petal. Use plenty of paint on each stroke, but do not blend at all at this stage. The paint now is used almost straight from the tube, with very little water.

Turn now to the bright green on the central flower. Mix up a light green using cadmium lemon, ultramarine and mixing white.

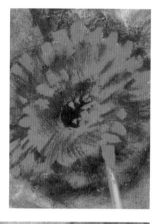

Still using the no. 9 brush, mix yellow ochre, cadmium lemon and ultramarine, and start to work on the leaves. The initial mix needed more ultramarine added to work effectively. This green has to be fairly dark as it has to cut out the flower.

RIGHT The next stage is to build up the orange flowers. For the first time white will be used. Take a no. 6, 4, and a 3 so that you can use one brushmark for each petal. Add mixing white to orange.

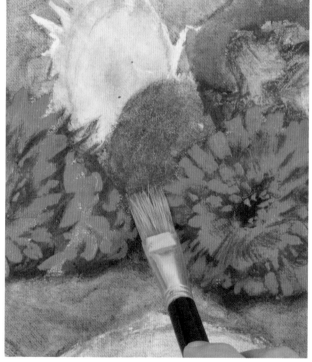

STEP 8 ▸▸

STEP 9 ▸▸

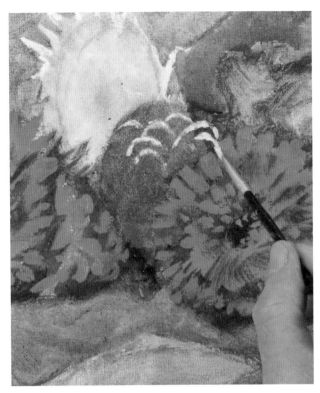

RIGHT Use the sable brush to draw with the paint, rather than for adding paint in large patches. Add a little more white to the mix and start to crisp up some of the marks against the other colours. Try to keep the brush relaxed in your hand.

As the effect of the water on the canvas is diminished as it dries, so the marks become crisper and you get a good mix of washy and solid marks.

Take a no. 2 hog with cadmium lemon, white and no water and look at some of the curved petals. Each time let the paint run. Keep repeating the beauty of the curves. Some of these curves cut back onto the green leaves.

RIGHT For fine brushstrokes use your sable. Some marks are thinner as they are going onto damp canvas. The petals just catch the light in different directions, creating the look of a curly mop.

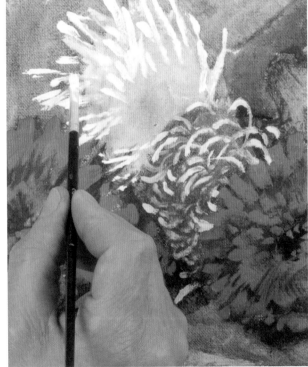

STEP 10 ▸▸

STEP 11 ▸▸

6
bunch of flowers

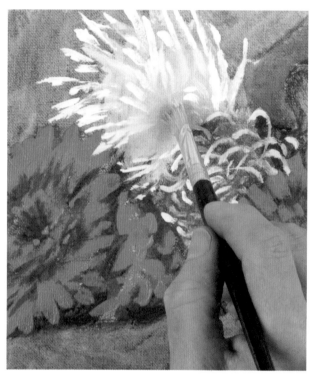

RIGHT Work in some shadows using the glaze. The glaze re-establishes the shadow areas on both orange blooms. The glaze can be moderated by adding more red to it to get a more intense colour onto the blooms.

Build up contrast by toning down areas and then working them up again. Make sure there is enough water with the cadmium red to allow the underlying colour to show through.

Turn to the white flower. Look again at where the light is coming from and start to add white petals. The shadows on this flower are already in place.

RIGHT Now go back to the orange flowers, and mix a glaze to give a richness to them. Take some cadmium red with a touch of violet added and plenty of water to make a thin wash, glaze over some areas of the flower. Dab with a cloth so that the effect is not too strong.

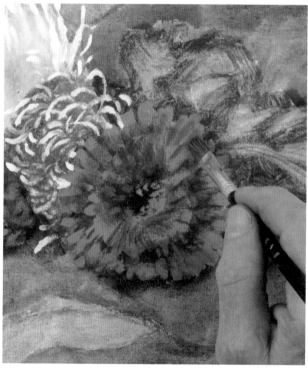

STEP 12 ▶▶

STEP 13 ▶▶

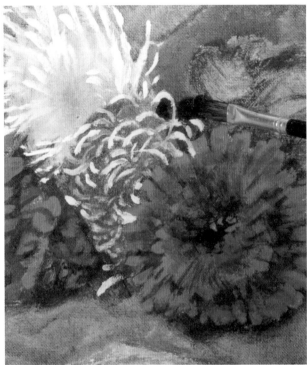

RIGHT Use some violet and a touch of Payne's gray to establish a few, not too strong, darks between the petals of the white flower. You can alter the shape of the petal, but don't overdo this, and keep plenty of water in the mix.

There are some darker marks in the centre of the white flower. Mix ultramarine and lots of cadmium lemon so that the colour is not too strong and add a few little green marks to the centre of the flower.

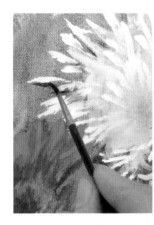

Reinforce the shadows on the leaves at this point. Take the ultramarine and cadmium lemon mix and add some Payne's gray to give a really dark colour to contrast with the crispness of the petals. Pick out the dark shapes, sharpening them with the aid of the sable brush.

RIGHT Contrive the shadows on the leaves to outline the shape of the petals. Smooth some of these off with a dry brush. You do not want edges in the leaves.

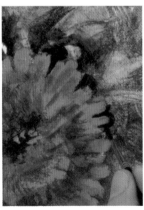

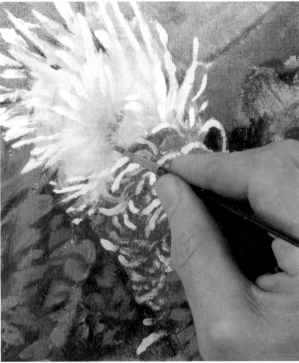

STEP 14 ▸▸

STEP 15 ▸▸

6
bunch of flowers

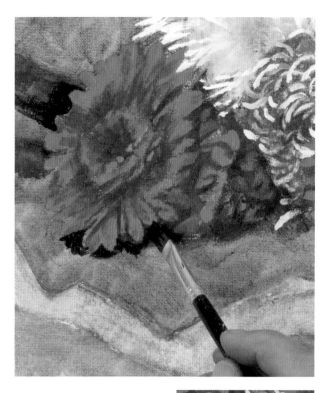

Strengthen the background to get some more contrast. Work a little more violet into the paper.

RIGHT Work the shadow of the paper. Keeping the background somber enhances the colour of the flowers. Then rub some shadow colour into the pale band under the paper.

Now bring up the edges of some of the orange petals. Mix orange, white and a little cadmium yellow for this and use a fairly stiff white to get some body into it. Half close your eyes as you look for the lightest areas. You do not want to become too botanical about this, but pick up highlights. Use the heel of the brush by the ferrule, and use the softness of the hairs to make your marks. Press the brush gently onto the canvas and drag almost pure colour onto the canvas.

DRYING TIME

Take care, if your hand rests on the canvas, that it is doing so on a dry area. Often with acrylics you will find as you move from working on one area to another that the colours have dried, especially if they were not too thickly applied to start with. It is still worth checking, rather than risking smudges.

STEP 16 ▸▸

STEP 17 ▸▸

RIGHT Note that there are some yellow highlights in the centre of the orange flowers. Stipple on pure cadmium yellow with a light touch.

The violet is now looking a little flat. To remedy this, scumble in some white paint. Water the paint down well and with a clean brush, lighten the tone of the violet. Scrub in some colour, to alter the 'feel' of the painting.

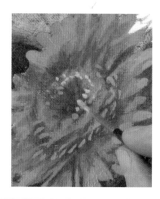

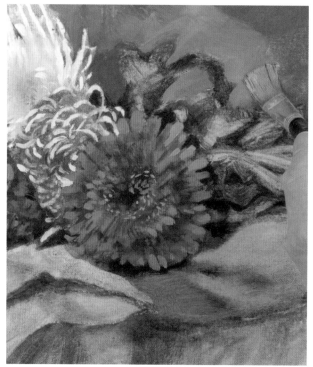

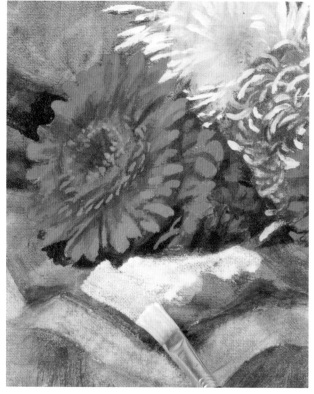

Neutralise the purple a little by scumbling on some Payne's gray: it is looking too powerful. The purple should not detract from the flowers, which are the main focus of the composition. Tone it down with ultramarine, then bring up the profile of the leaf.

RIGHT The two orange flowers are now looking too similar in size and shape, so scumble some colour onto them, to cast shadows and make them look different.

STEP 18 ▸▸ **STEP 19**

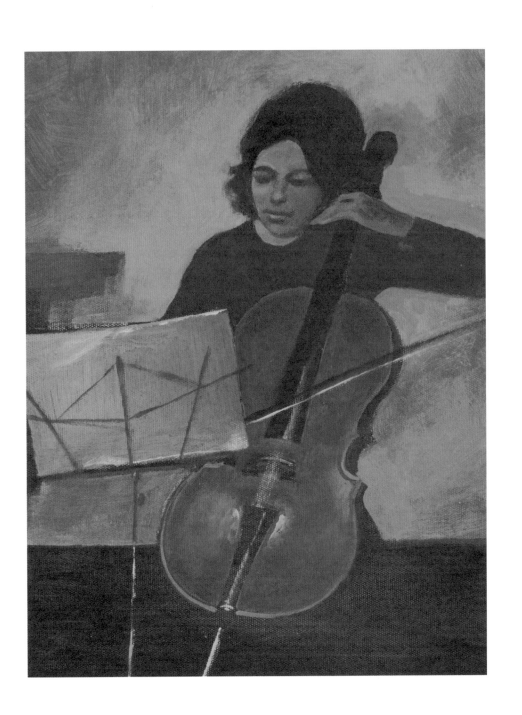

7
cellist
john barber
340 x 250mm (13½ x 10in)

From the start, the aim in this project is to reduce all the forms to flat areas with little or no modelling, and concentrate entirely on shapes and especially how shapes sit in the background, and the spaces between them. These are sometimes referred to as 'negative shapes'. If you pay attention to those which surround the figure and judge them by their relation to the edges of your picture, you can constantly check their accuracy one against the other. In this project the player and the cello are almost a single shape with the face and hand no more detailed than the instrument. The diagonal angles of the bow and music stand steady the composition and show the only directional light in the picture.

WHAT YOU WILL NEED

Canvas board
Brushes: 25mm (1in) decorator's; flat hoghairs nos 7 and 12; pointed sable no. 3
White chalk
Kitchen paper
Mahl stick

COLOUR MIXES

1 Payne's gray
3 Burnt sienna
4 Yellow ochre
7 Orange
8 Cadmium red

TECHNIQUES FOR THE PROJECT

Working from dark to light

Figure painting

Limited warm palette

PAINTING THE THIRD DIMENSION

Here in a simple and not over-elaborated exercise, the principles laid out in project 1 with the vegetable painting, are taken a stage further to cope with painting objects in three dimensions. A flat or textured area of ground tint outlined in light paint to accurately enclose the shape of a chosen object is easy to understand. A white line snaking out captures the object. By step 2, the method is probably quite clear. Properly understood, this method of realising objects in painted space, coupled with careful study of the principle, as used by the Old Masters will give you an insight into the way many great painters worked. A simple jug or pot painted in this way can, in the hands of a skillful painter, produce visually satisfying images with the power to calm the viewer. The great Spanish painter Diego Velásquez (1599–1660) perfectly realised the kitchen pots and pans in his pictures where they often grabbed the attention from his figures. He used the reverse technique from that shown here, outlining his pots in black to make the somber earth colours stand out against his dark background, as did Jean-Baptiste-Siméon Chardin (1699–1779) a century later, when they became his sole subject matter in some pictures. Even Pablo Picasso (1881–1973) in his 'Classical' periods, used exactly the same technique for his monumental figures.

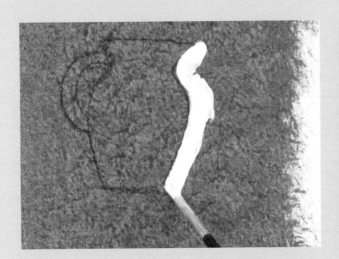

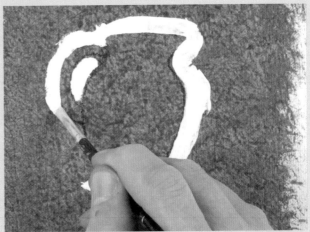

1 Tint a piece of canvas with a neutral colour which will become the middle tone of your subject. Mix some water with your acrylic paint and stipple it on roughly. Draw the silhouette of a jug with charcoal or chalk. Start to outline it in white.

2 Using a small hoghair brush, work around the outline of your chosen subject. Load your brush well and use the side of the brush as your drawing tool to complete the outline of your shape. Fill in the space to create the shape for the handle.

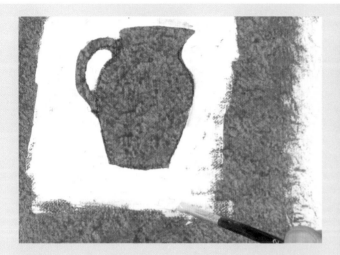

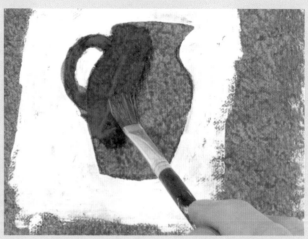

3 Cover the rest of the background with the light paint so that the form is isolated. At this point, the subject is clearly recognisable. An accurate flat shape tells us everything about the object, except the illusion of modelling.

4 Mix up a darker ultramarine colour for your shadow area and paint down one side of the jug, taking care not to go over the edges. If you do paint into the white, retouch the light background later, when the paint is dry.

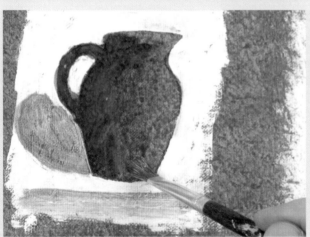

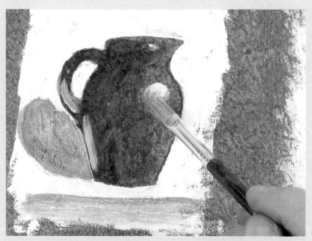

5 Before the dark shading colour is dry, take a damp brush and blend down the right-hand side of the shadow. Try to get a smooth transition of tone so that the shadow fades out about halfway across the jug, following the curve of the outline.

6 Take your light background colour and place highlights: a small crisp one on the near lip of the jug, and a large blended one on the shoulder. Blend a little back lighting on the handle and in the shadow. Add cast shadows to complete the exercise.

This study will be fairly monochromatic using a restricted palette, so start by tinting a canvas. Mix Payne's gray and burnt sienna and apply using a large brush. The background tint has no white in it, so the texture of the canvas is still visible. Cover the whole canvas, without being too precious about mixing the two colours. Both are applied to the canvas and will be mixed on the canvas.

FIGURE DRAWING

The purpose of this project is to show how far you can get with figure painting, without needing the level of skill required for portraiture. This essentially monochrome study is a series of shapes that give a lot of information about figures. There is very little detail in the face, body, or in the cello.

Work across and down the canvas, making the colour more even. Wash some Payne's gray over the mix, to darken the canvas down even more. This project will be worked from dark to light. Once the background is dry, establish the main lines of the composition using white chalk.

RIGHT First, mix up a solid colour of yellow ochre, titanium white, and Payne's gray. Starting with the shoulder, draw round the figure and the head.

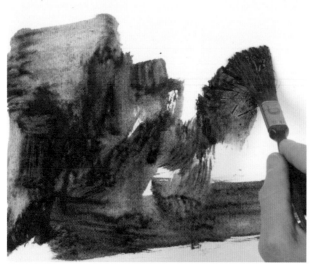

STEP 1 ▸▸

STEP 2 ▸▸

Then work around the cello and down the arm. This colour mix will be the lightest tone in the painting. Make sure that your paint is stiff, but flows and keep plenty on the brush. Use one corner of your flat brush as a drawing tool to define the lines of your composition. Work with a full brush to cover the background colour well. Work around the other side of the cello. Add in the floor line, then work around the head, covering the background tint.

MARGIN FOR ERROR

With a composition like this one, it is worth leaving yourself a margin for error. You can make the main elements smaller by re-defining their profiles later. In this painting, the cello was left larger than its finished size in the early stages and refined later, and the size and shape of the head were also adjusted.

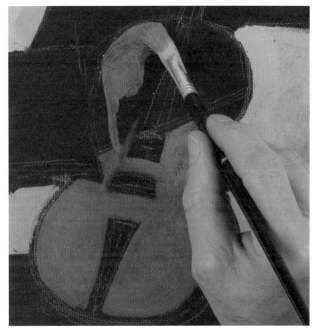

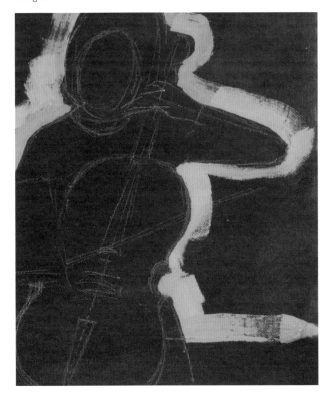

To this colour mix, add some burnt sienna for the instrument. This needs to be a rich colour, so add some cadmium red. Get the tone in here as a flat colour. Once all the basic shapes are filled in, you can start to build up tones. Don't worry about the bow at the moment, but leave space for the bridge and sounding board. Use the edge of your flat brush as your drawing tool.

RIGHT Put a tone on the area of the music by mixing yellow ochre, Payne's gray and white. This is in shadow so don't make the colour mix too bright.

STEP 3 ▸▸

STEP 4 ▸▸

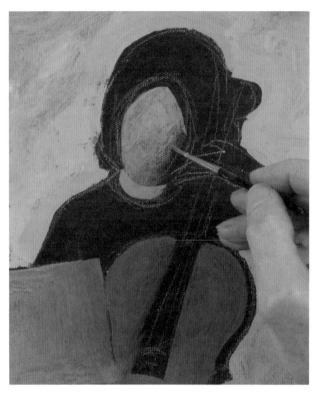

RIGHT To define the shapes of the flesh areas, use this same brown mix to create the shapes of the shadows. Work the areas around the eyes: these work simply as dark shapes, rather than as eyes or eyelashes.

Work into the side of the face, creating the shadow there.

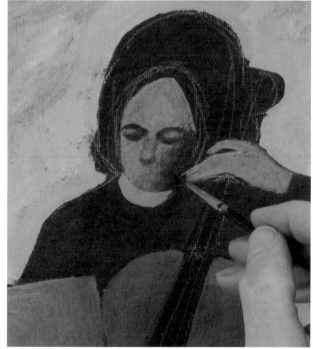

Use a mix of burnt sienna, yellow ochre, and white for the areas in the light, then add a touch of Payne's gray for the shadow areas. Paint the face and neck.

RIGHT Draw the shape of the hand as accurately as you can. Take some burnt sienna and Payne's gray to mix a brown for the cellist's top: the colour change is not going to be all that great. Work across her top and down the arm.

STEP 5 ▸▸

STEP 6 ▸▸

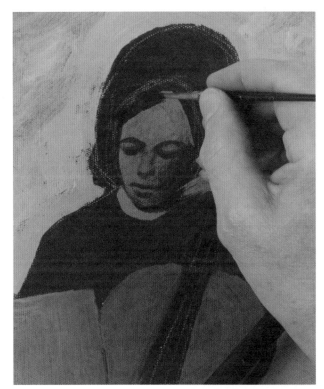

RIGHT Notice that the area of the neck is lighter than the face because the neck is tilted up, while the face is tilted down. Now, add a slightly lighter tone to the fingers.

Look again at the shape of the head. It is clear there is too much hair. Use yellow ochre and white to re-define the area of the hair. Outline the area that should not be hair, then fill it in.

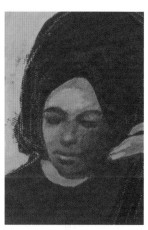

Now the features are drawn in proportion, the face is clearly too large, so the hairline needs bringing down to make the face smaller. Go from the features of the face and the areas of shadow and get the hair right. Her forehead is too high, and needs cutting down dramatically.

RIGHT There is a slight change of tone as you come down the nose. There is also a highlight on the lip although this is very subtle.

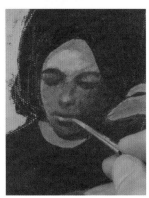

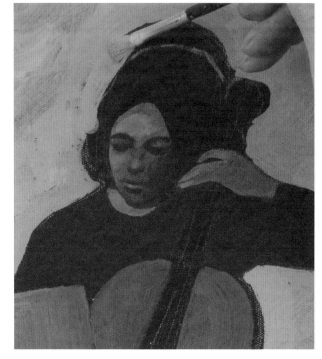

STEP 7 ▸▸

STEP 8 ▸▸

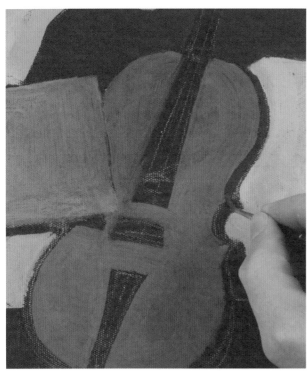

RIGHT Work the same reddish colour mix over the right-hand side of the cello, to clarify the area where the body of the instrument is joined to its edge.

Wet the brush, touch it into the paint and dab off some colour, using paper towels, to get rid the chalk marks.

Turn your attention to the cello next. Add some of your mix of Payne's gray and burnt sienna to the side of the cello, where it is in shadow. This also helps to define the shape of the instrument.

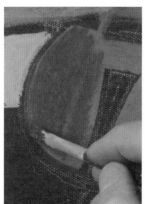

RIGHT Tone down the colour of the cello, making it richer and redder by adding some cadmium red to your mix of burnt sienna and Payne's gray.

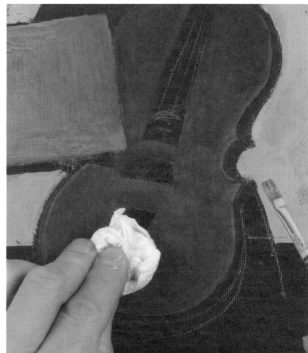

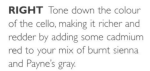

STEP 9 ▶▶ STEP 10 ▶▶

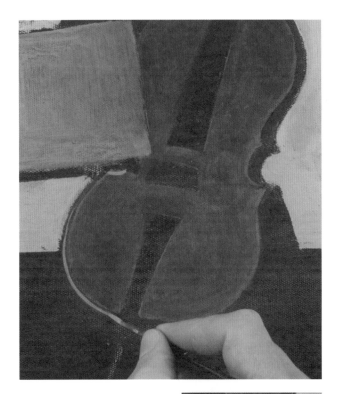

RIGHT Use a wet brush to tone in the colour on the top right of the cello. The changes of tone in the polished wood are slight and mixed on the canvas.

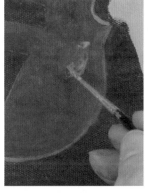

There is another highlight to the right of the scaleboard, so work this in: this too is a very slight colour change.

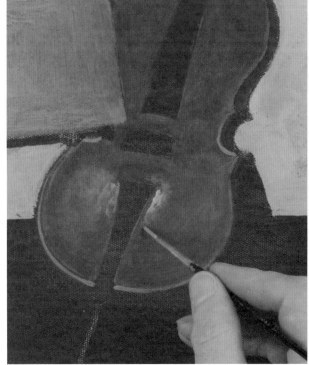

Mix yellow ochre and white, with a touch of orange and use this to work some slight changes of tone on the cello. There is a highlight around the left-hand edge of the base of the cello.

RIGHT There is another highlight on the upper edge of the right-hand side of the instrument.

STEP 11 ▶▶

STEP 12 ▶▶

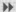

Blend colour in the lightest areas. You are also creating the detail of the carving on the wood when you add colour here.

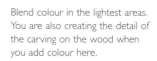

With a figure subject it is important to see the face and hands as simple shapes. A continual checking of the size and position of each colour patch will enable you to get an overall balance. Once all the elements are worked up to a consistent level, you can elaborate further if you wish.

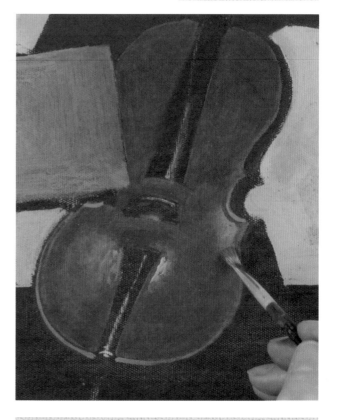

The brightest area on the cello is behind the scaleboard.

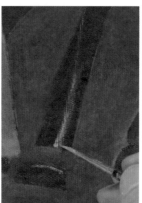

RIGHT Work over this line to sharpen it up. This is visually linked to the spike, which will be added in later.

STEP 13 ▶▶

STEP 14 ▶▶

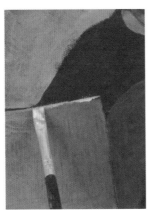

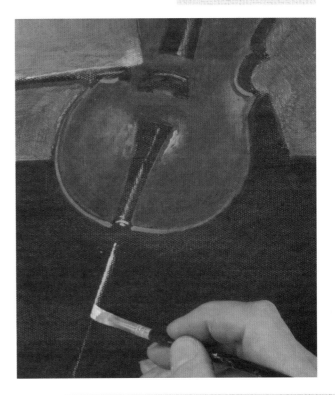

Now the shoulder looks too wide, so adjust that and then work one or two highlights behind the figure. All the time you are adding paint, you are refining your drawing. Then turn to the spike and work that using the tips of the bristles. For the music stand, make a vertical and create legs.

CHANGE YOUR MIND

Acrylic paints let you change your mind as often as you wish and often re-painting seems to add to the attractiveness of the paint surface. If you paint in an opaque manner, using white in your mixes, there are advantages in layering your paint thickly. One is that acrylics do not peel when one layer is overlaid on another.

The background colour is too harsh and needs to be toned down. Scumble in a grey tone. Mix some yellow ochre and Payne's gray and block this in, using a no. 12 flat hog brush. Once this background has been toned down, it can be pulled back by adding some white to it.

RIGHT Turn now to the music sheet and add highlights along the top edge and in the bottom right-hand corner.

STEP 15 ▸▸

STEP 16 ▸▸

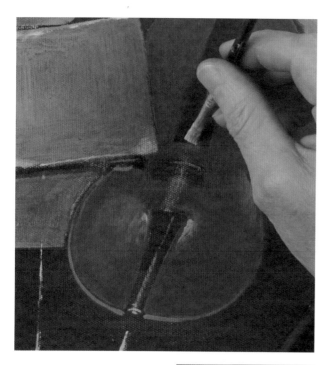

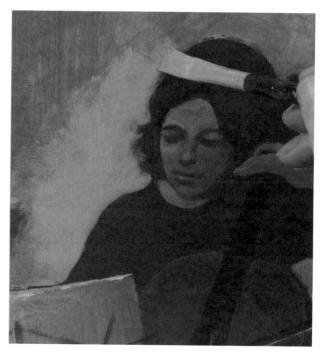

Indicate some strings with one long brushstroke: you may need to use a mahl stick or straight edge to steady your hand.

RIGHT Take some Payne's gray and draw in the darks on the music sheet.

Draw in the black line of the bow. Then slightly alter the cellist's top. Pick out some highlights on the arm to define the forearm better. Then get some modelling into the body. Mix some yellow ochre and Payne's gray and use this to refine the shoulder some more. Then work around the head, improving the profile of the hair.

TRICK OF THE TRADE

Acrylics can be mixed with acrylic gel medium which lets them flow more easily without having to add too much water so that the colour film becomes too thin. Another trick is to wet the canvas once your painting has dried, and paint into the damp canvas. This gives a soft, flowing effect to the paint and makes it easier to blend your colours.

STEP 17 ▸▸

STEP 18 ▸▸

RIGHT Work down her shoulder, using your brush as a drawing tool to improve the shape of the upper arm.

Now that the painting is almost complete, it is clear that the hand appears to be in the wrong place, so bring it down the neck of the cello. Bringing this down means that the head of the cello also needs to come down. With acrylics, such 'mistakes' are easy to rectify by overpainting. Add some darks to the hair, then re-position the hand and make it smaller.

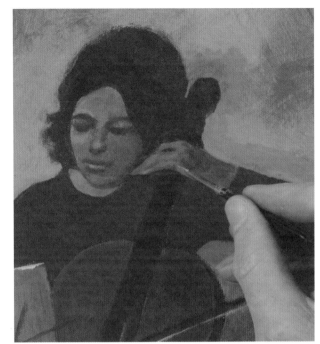

Add a little shadow on the back of the hand.

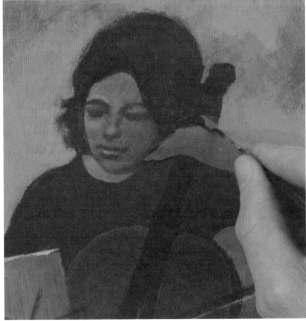

RIGHT Finally improve the outline of the top against the neck. Look again at your painting to check that you are satisfied. Although this painting seemed to be finished, on closer reflection it was apparent that the whole area of the hair was still too large, so that was reduced still further.

STEP I9 ▶▶

STEP 20

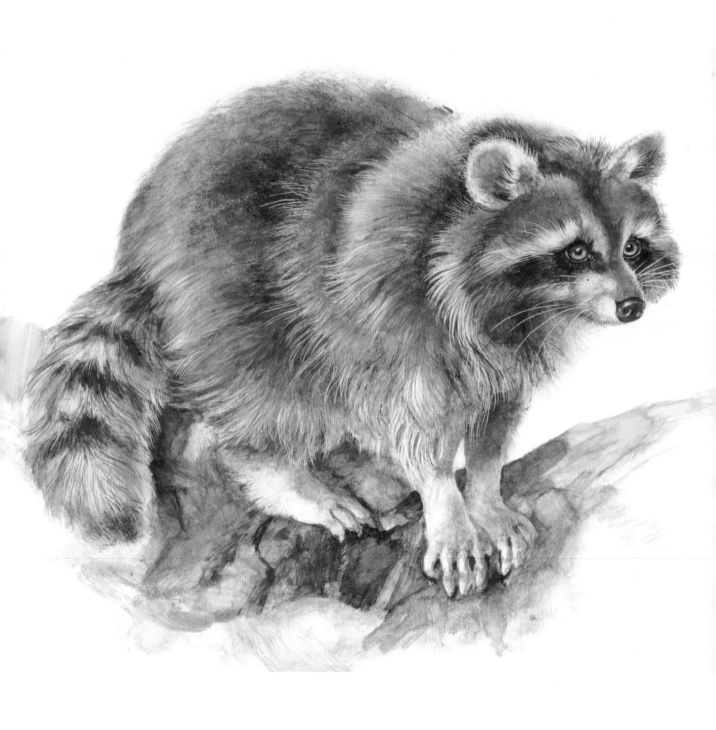

8

raccoon

john barber

345 x 460 mm (13½ x 18 in)

This project takes a more illustrative look at an appealing little animal with bandit mask and dainty white feet. The technique aims at a realistic rendering of fine detail in the features and the fur. The eyes in a portrait like this one are drawn very carefully and completed first. The disk of the eye and the shape of the pupil are important but the eye itself has no expression. It is muscles and colour around the eye that hold the secret of expression. The textures of fur vary, but the dynamics of fur, the way it lies, divides, and sticks up on end, must be observed carefully. With a little practice drawing individual hairs is not so difficult but preserving a sense of the anatomy under the fur certainly is.

TECHNIQUES FOR THE PROJECT

Blending and stippling

Scratching back to surface

Wiping out

WHAT YOU WILL NEED

Smooth illustration board
Graphite pencil, 2B
Brushes: flat hoghairs nos 4, 6, and 7; round sables nos 2, 4, and 6
Craft knife

COLOUR MIXES

1 Payne's gray
3 Burnt sienna
4 Yellow ochre
12 Ultramarine

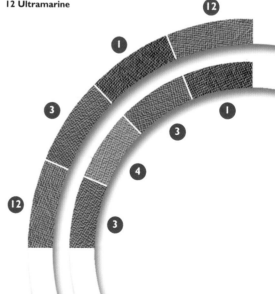

SCRATCHING THROUGH

This exercise introduces you to the technique of scratching into wet or dry paint, a procedure which like most of the advice in this book, has a long tradition of use in many kinds of picture-making. It was used a great deal in fresco mural work and is in essence a loose form of engraving, sometimes referred to as *sgraffito* work. When the tool is a pointed brush handle which must be used on wet paint, it scrapes through the paint to the surface of the panel. Lines made in this way are often accentuated by the line of wet paint pushed to one side by the scraping tool, so making the sense of depth doubly effective. Much used by 19th-century watercolourists, working with gum arabic to thicken their paint, it works even better with modern acrylics to develop detailed passages in foregrounds of fine-stemmed plants and grasses and in the depiction of fur and feathers. The use of stiff brushes to make many parallel lines on a smooth panel makes an ideal ground for elaborate linework drawn over it. The brush handle work is followed when the paint has dried completely by scraping through with the scalpel or craft knife, sometimes merely scratching and at others cutting in to the surface of the panel to reveal the pure white coating. Practice this until your scalpel lines are as predictable as your handwriting.

I Start by using a stiff hoghair brush to push thin paint outward from a centre point so that at the end of the stroke, the bristles leave a ragged edge. Textures like this are easy to do with acrylics, especially if the surface is smooth.

2 Do not mix the water too thoroughly with the paint While the paint is still wet, you can begin to scratch lines out of the background texture with a brush handle. As here a scalpel or craft knife can be used to create finer lines.

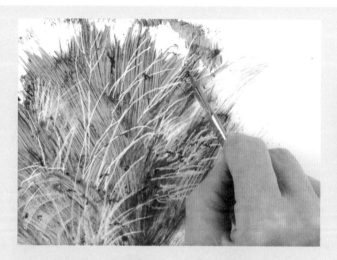

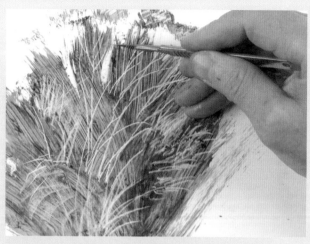

3 Continue to scratch radiating lines as if you were picking out blades of fine grasses. Starting at the base, swing your blade in a series of curves, making sure that some lines cross each other for even greater realism.

4 Now start adding some fine straight lines and short flicks. Join some lines at an angle to suggest dividing stems and some disconnected short strokes to suggest seeds. Don't plan it too carefully: just keep scratching and keep the marks lively.

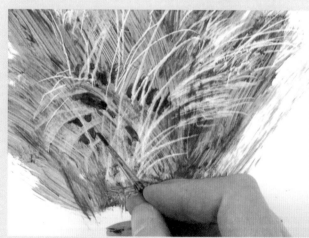

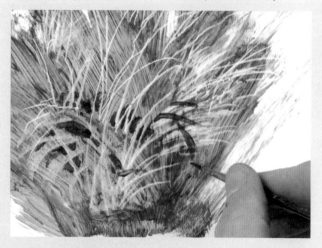

5 On the left, there are curved marks made with the side of the blade. These only scrape part of the paint for a lighter background shade. Take a small sable dipped in the background colour and fill in some of the gaps and interstices.

6 By leaving the lines that most suggest blades of grass or leaves you can build up convincing detail in quite a short time. Finish by drawing with the brush a few dark lines across some of your scratched lines to give a sense of extra depth.

raccoon

Draw or trace your subject. Before starting to paint, check the accuracy of a tracing to make sure you have not missed any important lines and refine the finer lines of the illustration. With most paintings your aim is to block in the main shapes, but with an animal study, block in the eyes and the shape of the head, to get the animal's character down first. This applies to portraits of both wild and domestic animals. Clean up any pencil marks in the eye.

CHOICE OF SURFACE

This project is worked on a smooth illustration board, that is non-absorbent. On a smooth board, every brushstroke shows; on canvas, the brushstrokes are broken up, which helps with colour blending. On this type of detailed illustration, however, you want every brushstroke to show, and not to break up.

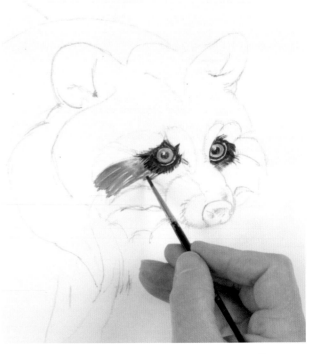

Burnt sienna is a pure red, so use a minimal amount of this for the eye. Put the pupils in, then outline the eye using Payne's gray. Begin to draw the dark outlines of the eyes, building up fine marks. Note that the paint here is a little stiffer than was used for the pupils. Then make a more watery mix and start to indicate fur.

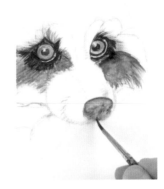

RIGHT Take your smallest sable and Payne's gray and colour the nose. This establishes the head.

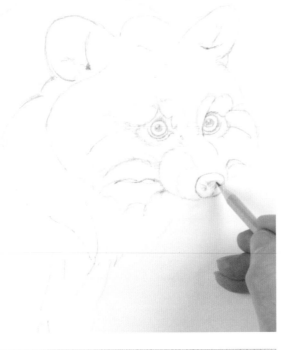

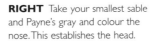

STEP 1

STEP 2

Now switch to a hoghair brush to start creating more vigorous marks. Take a no. 7, and use it in a stippling fashion to give a light grey to areas of the face. This defines the light and dark areas, but will not be the final colour of the face. On the smooth surface each hair of a hog brush leaves a mark. Push the paint, rather than dragging it, always guiding your brush in the direction the fur is growing: keep reminding yourself what this is.

TRICK OF THE TRADE

Always have a spare piece of board of the same texture and absorbency as the one you are working on at hand. That way, you can test the strength of colour and the texture of your brushmarks as you work, before you add them to the illustration board.

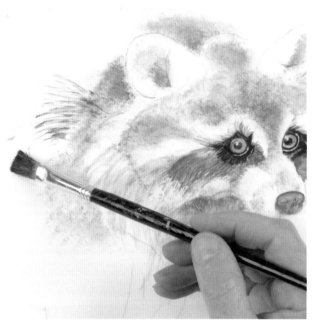

Work some shadow inside one ear, then the other. At the moment the board is acting as your white pigment, so some areas need to be preserved so that you can still see where the fur is white. Use the hog brush with stiffer paint, to work the hairs coming out from the head, since these are coarser in texture.

RIGHT Use a more stippling action down the nose. Stroke the paint into the white areas to make them less stark, but keep white showing through. Darken the area around the eye.

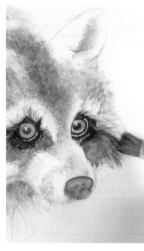

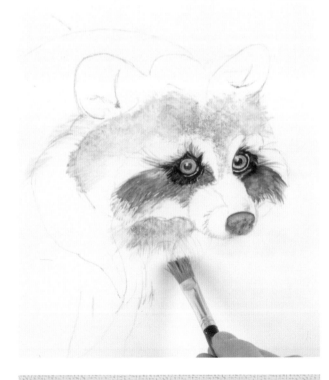

STEP 3 ▶▶

STEP 4 ▶▶

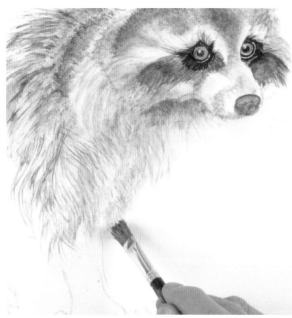

RIGHT The collar or ruff is defined by the marks you make now. Rub some colour into them to define the light and dark areas, and give a degree of modelling.

Always follow the direction of the hairs, but keep the underlying anatomy of the body in mind as you start to build up the fur. The trick is to keep the brush moving, so that your marks do not lose vigour. Keep the brushmarks parallel and in the direction in which the fur is growing.

One of the advantages of using acrylics for this type of painting is that by the time you work back into it, it is dry so you are not lifting wet colour, as you would in watercolour. If you make a mark that is too strong, dab it off with your finger straightaway. You can achieve almost microscopic texture on the hairs, where you need it.

RIGHT When you start to run out of paint on the brush, use it to add pigment to those areas that need a light touch, for example on the chest. Then define the feet as separate by creating the shadow between them.

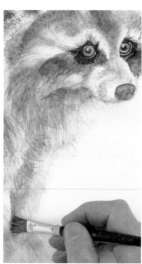

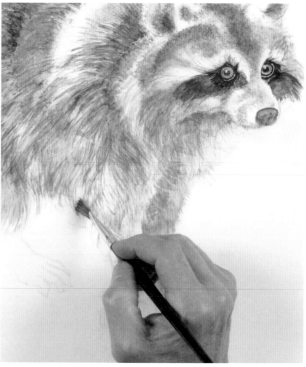

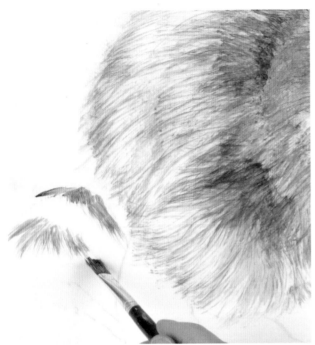

RIGHT Put the Payne's gray aside for a time, and switch to a no. 6 hog brush. Take up some yellow ochre and start to add a thin wash into the areas of densest fur. You do not need much paint, as you do not want to obscure the light and shade you have built up, but even a little colour changes the painting significantly. Dab colour on, then smooth it out.

Create a fine stipple over the top of the head and down the nose.

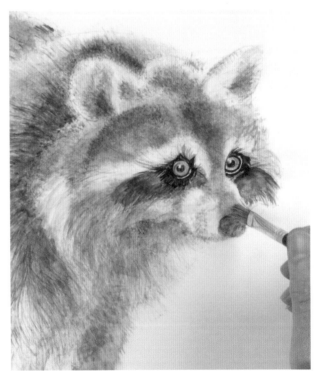

What you have created at this stage are areas of light and shadow over the whole animal. Now indicate the dark bands on the tail, with almost solid Payne's gray. The tail is coming toward the viewer, so the hairs are pointing in that direction.

RIGHT Where the hair faces toward you, use the brush almost vertically to 'bounce' paint onto the board. Drag some texture into the area of the light bands on the tail. Then indicate some texture in the foot area: this will be returned to later.

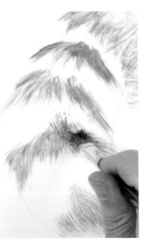

STEP 7 ▶▶

STEP 8 ▶▶

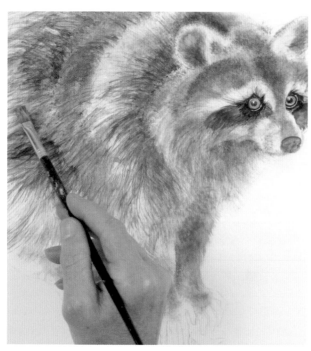

RIGHT Using the same colour and a dry brush and keeping your brush moving, create the darkest areas on the back of the animal. These touches of black give a solidity to the colour.

Stippling with the black paint is gradually taking the overall tone of the painting down. This will allow you to add white highlights for the guard areas later.

Note that the colour is not being used to render hairs at all: it is simply being used as a cloud of colour over the hairs you have already worked. Push some colour up into the ear, then work with freer strokes and a washy consistency over the back.

RIGHT Give the tail a little more modelling by working the same colour into it. Then use a nearly dry brush with some pure black on it to define the areas of tail where the fur is almost pure black.

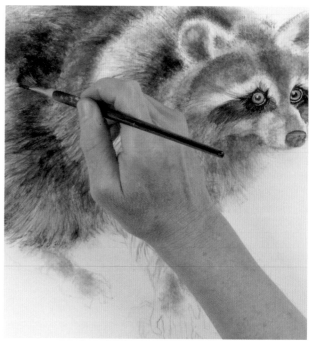

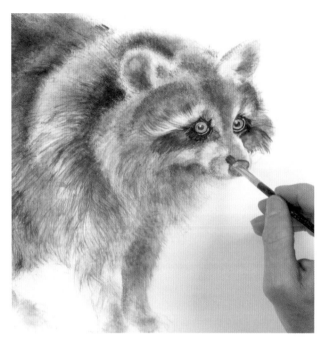

RIGHT Bring some darks up to where light edges have been left in the ears. The darkest area is behind the ear. Without outlining it, since the ear has lots of fine hairs, work some dark hairs into this area. Make the area above the eye slightly darker. This gives an edge to the facial hair.

Work some more stippling around the eye. Then add more burnt sienna into the area of the ears. The tuft that comes up is often quite reddish.

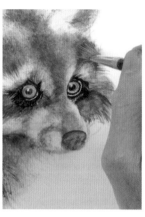

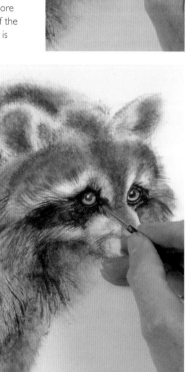

Move down to a no. 4 hog and start to work details in the finer areas such as on the head and around the eyes, again using black. Then sharpen the connection between the eye and muzzle.

RIGHT Add some black flicks into the chest and down the back and tail. Next work some more burnt sienna into the back to warm it a little. You need very little paint on the brush. Use the side of the brush and drag the paint in, building it up gradually. This warms the dark areas and gets rid of the cool airs.

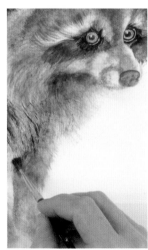

STEP 11 ▶▶

STEP 12 ▶▶

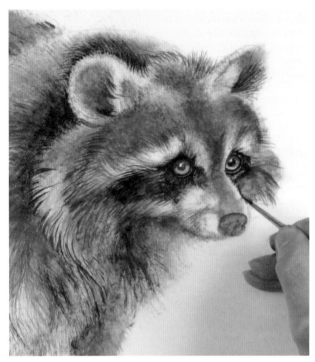

There is a lot of fine linear work in the tail. Use black to introduce these details. Keep the colour fairly thin so that the lines stay fine. Thin your colour out so that it is almost like a pale grey, and run parallel lines out in the direction of fur growth. You may need many hundreds of tiny parallel lines. Use the dark paint to superimpose a pattern over the soft tone you created previously.

STIPPLING TIPS

When working stippling such as that on the back of the raccoon in this project, always go to a new area, rather than overworking somewhere that is not yet dry, otherwise you risk moving the underlying paint. Keep looking at your work, to see a new area where you need the strength of colour that is already on your brush and move to that.

Use a very diluted black to create a grey to re-define some areas of your drawing. Then use the black to model the buttonlike nostrils. Use pure black and soften it, to keep the nose looking shiny. Next, work down the gap between the nostrils.

RIGHT Put some reddish-brown into the nose, to give the impression that it is coming toward you. There is a darkish area on the ear, so add some black here, over the burnt sienna.

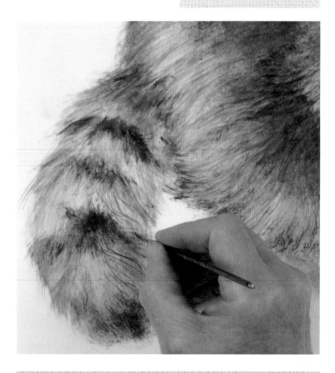

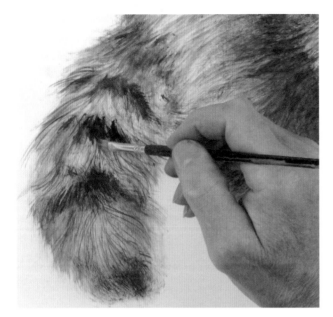

Mix burnt sienna and ultramarine and start to indicate a bit of background to anchor the raccoon. This mix can also be used to flick out the shadows of the hair. Work around and under the raccoon, flicking paint where it meets hair and, using broader strokes, blended with a tissue in larger, flatter areas. Work some glazing over the front limb and stipple it away to re-find your original tonal painting. This softens the effect of the brushwork and gives a nice deep tone. Then work the gaps between the toes.

TEMPERA TECHNIQUE

In egg tempera technique, the paint is laid in many layers of small spots, gradually building up colour without blending. Acrylic painters can use this approach since their colours also dry quickly and are not affected when more layers are added. As in this project, the best results come from the use of transparent colour over a white ground.

While the paint is still wet, use the hog brush to blend the colour. Note that some of these marks are quite strong.

RIGHT Turn now to the 'hands' and start to work some modelling into them. Use a soft no. 6 sable brush to blend and a no. 2 pointed sable to give an indication of the white feet. Indicate some grey shadow. Start with the back feet, then move on to the shadows of the 'fingers'. The cast shadows define the shape of the fingers. Put some marks into the leg, keeping the flow of the hairs rhythmic.

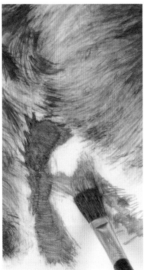

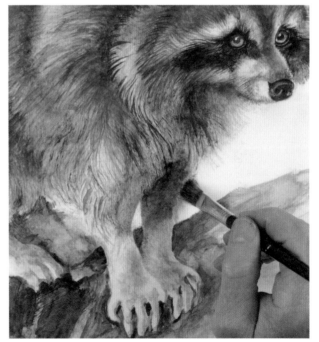

RIGHT Now take a scalpel and start to scratch out highlights. Don't start in the most crucial area. When you are confident, move to the areas of highlight around the eyes. Scratch down the 'beard', then down the chest.

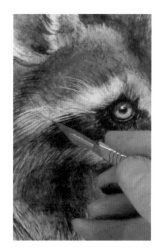

Keep your scratched marks going in the right direction for the growing fur. This may mean turning your work around. Either scratch out along your brushmarks, or alongside them.

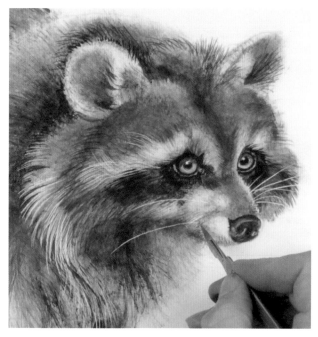

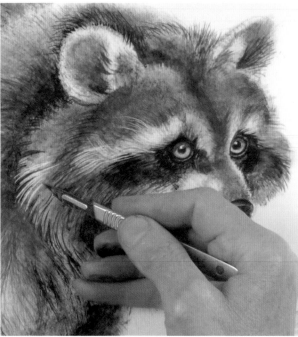

For the whiskers, put your blade firmly on the board, and in one movement flick out paint. If you don't like a line, paint over, let it dry, and start again. Aim for a mix of fine and coarse whiskers. Where a whisker extends outside the painting, add in a touch of dark paint later.

SCALPEL TECHNIQUES

Fit a new, sharp blade into your craft knife or scalpel. Paint a patch of black on a piece of spare board, and use this to practice flicking out scalpel marks. This will help you to get the right pressure and degree of movement you will need in your illustration. You can also use the flat blade of the scalpel as a clean-up tool but take care not to remove the board surface. From time to time flick off the paint shavings.

STEP 17 ▸▸

STEP 18 ▸▸

RIGHT Accentuate the animal's bandit mask and add a highlight to his nostril. There is a catch-all highlight in the nostril.

The leg hairs are long, and because raccoons spend time in water, they are often straggly. If you think you have overdone the scratching and it is starting to look too chalky, you can always work over it with paint again, to re-establish your darker areas. Work one or two long hairs, then scrape out some of the darker areas on the back.

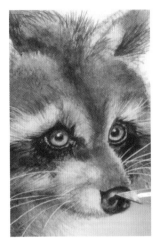

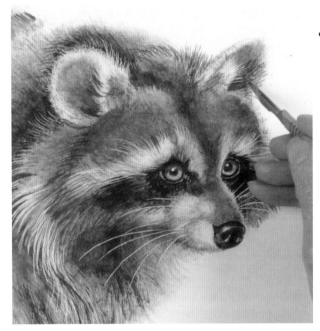

Take out some white highlights in the ear, then scrape out areas on the tail, and clean up around it to get back to your white board.

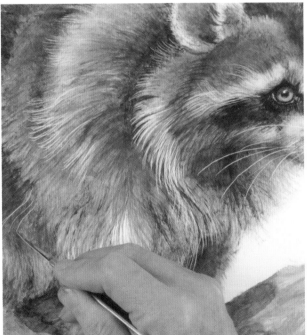

RIGHT Then turn to the toes, which are looking a little crude in comparison with the rest of the painting. Take a wash of yellow ochre and a touch of black, to model the feet a little more. You can also add some darks between the hairs to indicate that they might be wet.

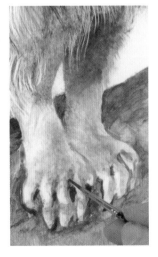

STEP 19 ▸▸

STEP 20

index

index

Picture credits
All artworks by John Barber except: p. 10 (top) © Mark
Leach; and pp. 40–49 © as credited to individual artists.

Author's acknowledgments
I would like to thank my wife, Theresa, for her loving
support during the countless hours I spent in the
studio preparing this book.

Publisher's acknowledgments
Axis Publishing would like to thank London Art Linited,
132 Finchley Road, London NW3 5HS for the loan of
materials for photography.
www.londonart-shop.co.uk